ITALY IN LOVE ♥

ART AND BEAUTY PRESS

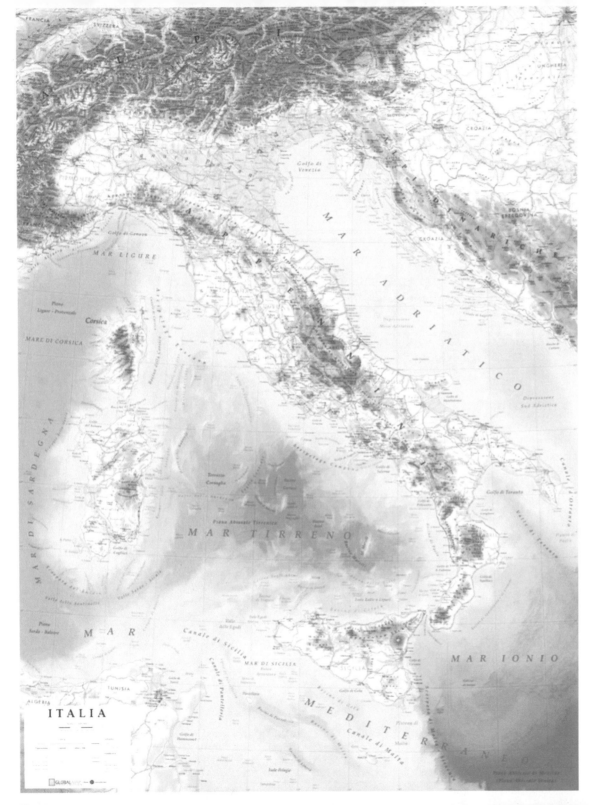

Italy is an incredible land that take your breath away.

Nestled in the Mediterranean Sea, offers beautiful landscapes between sea and mountains, and between lakes and forests.

Here you can find the best beaches and the best food in the world.

Be overwhelmed by the beauty of this country; you will fall in love immediately.

Are you ready for this amazing travel?

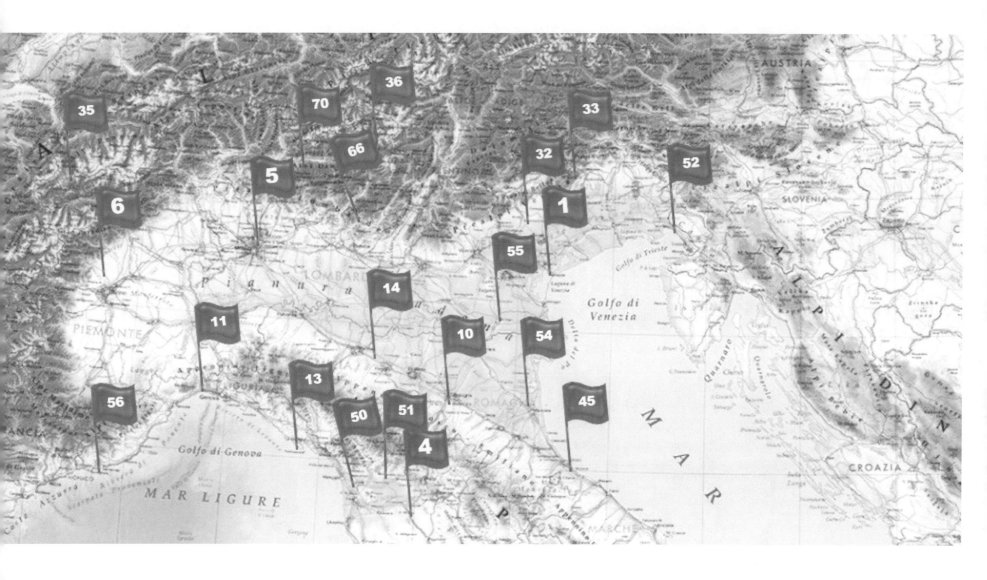

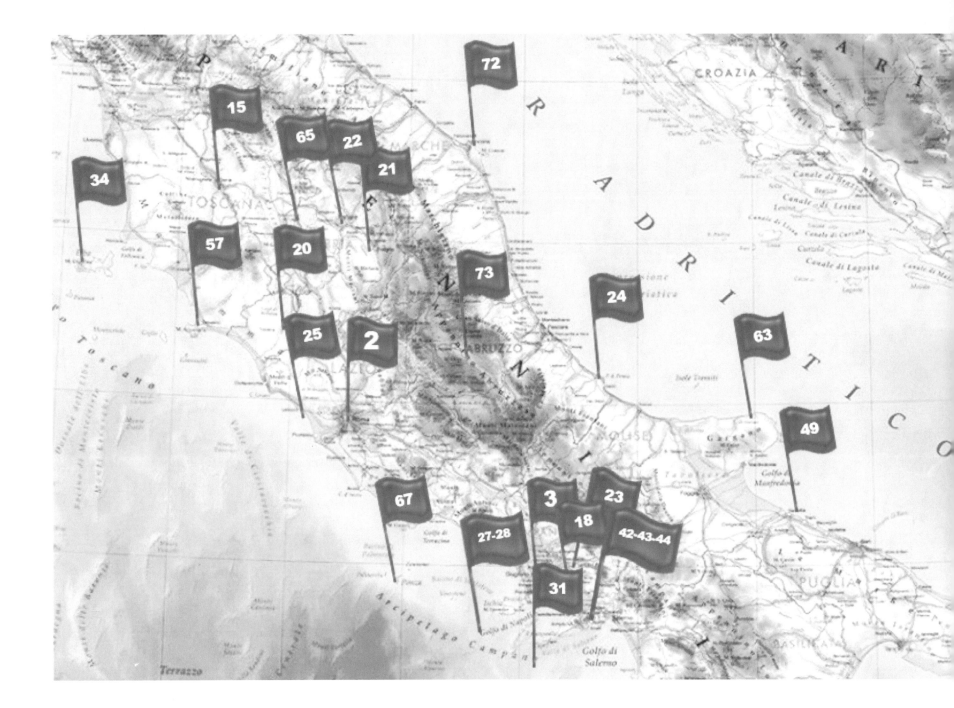

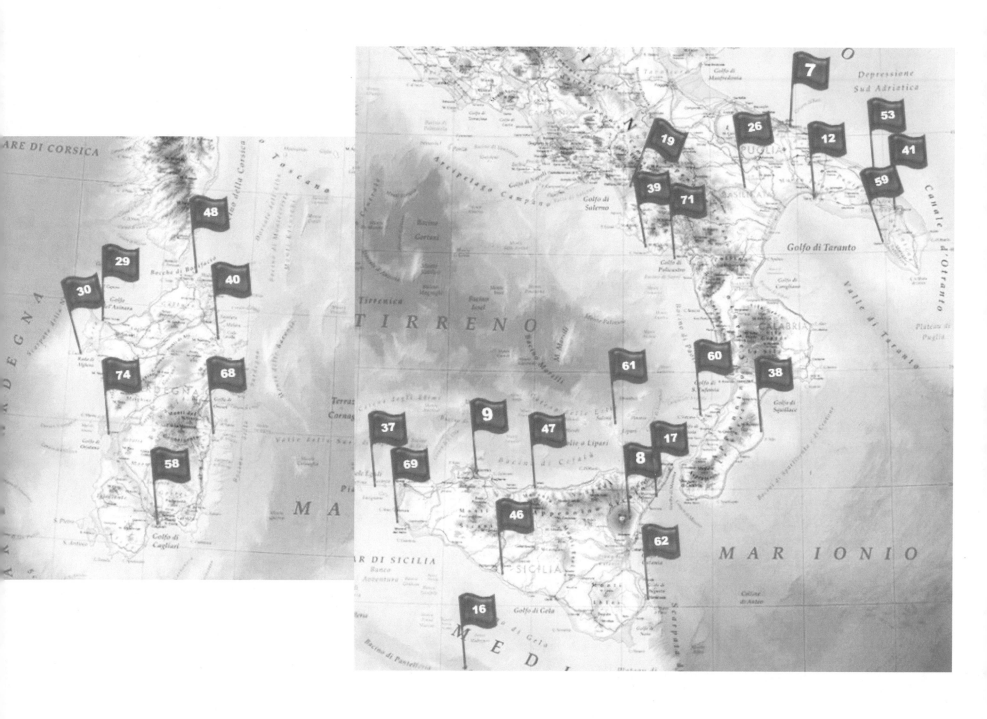

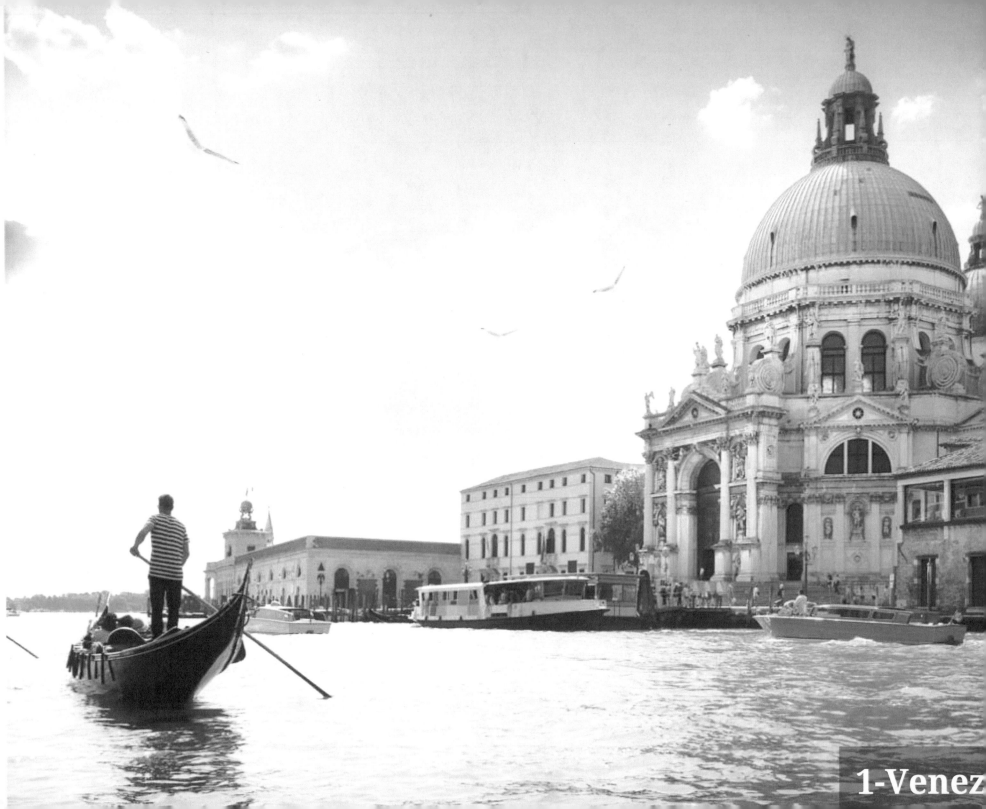

1-Venez

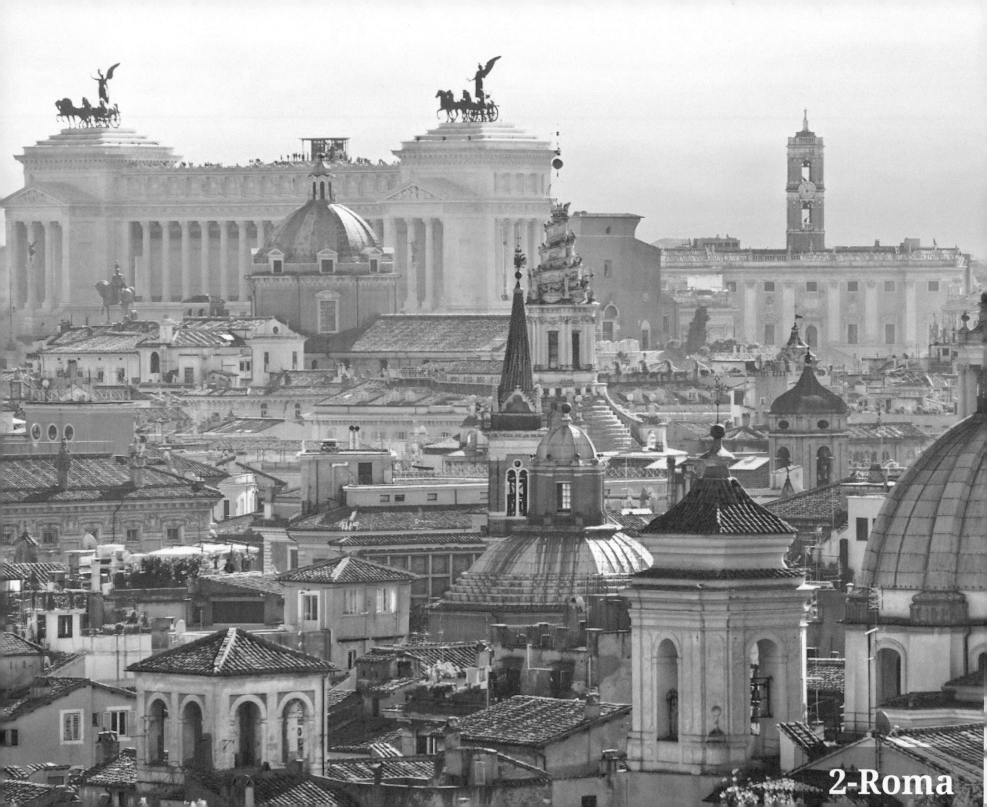

2-Roma

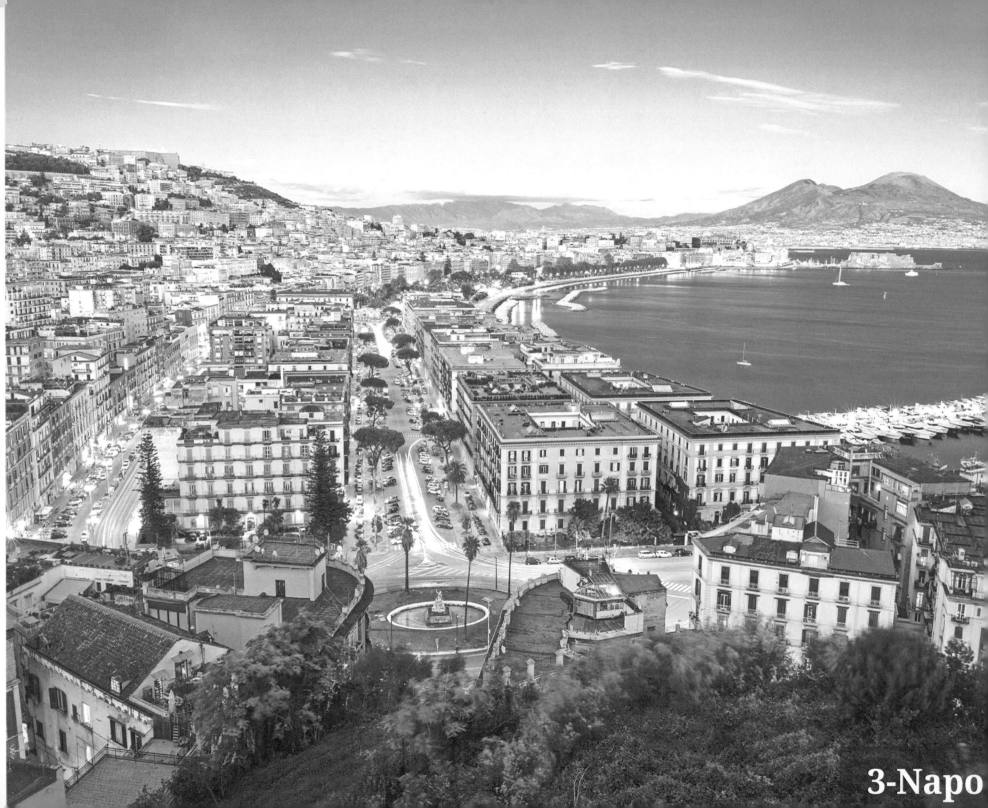

3-Napo

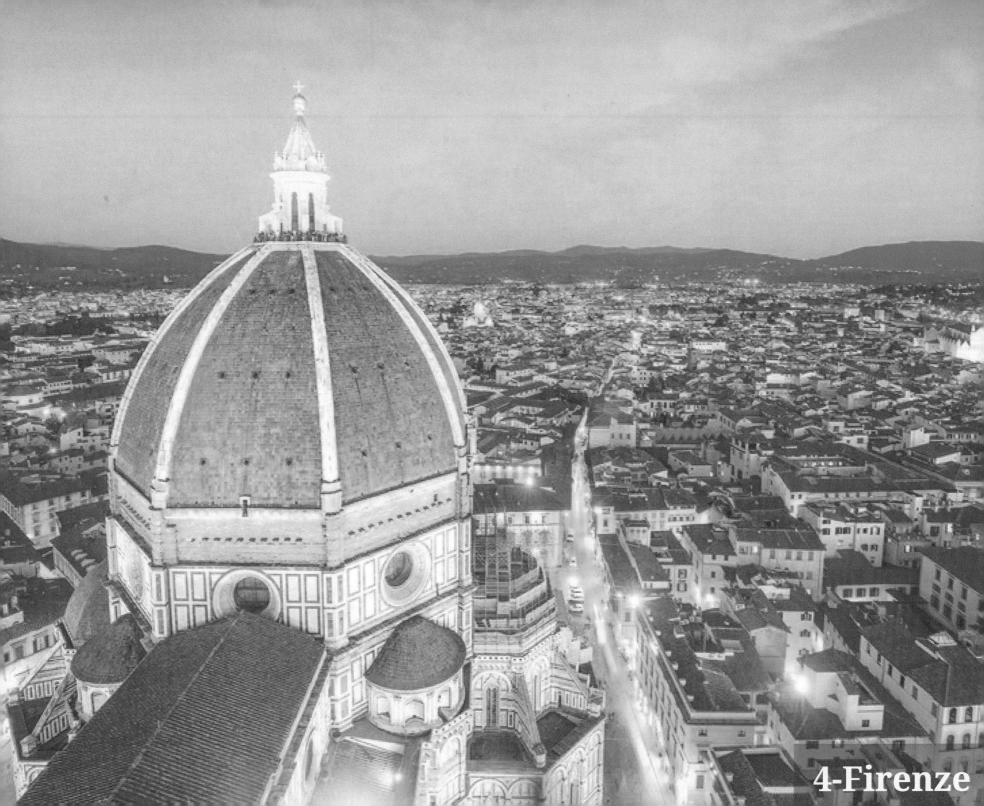

4-Firenze

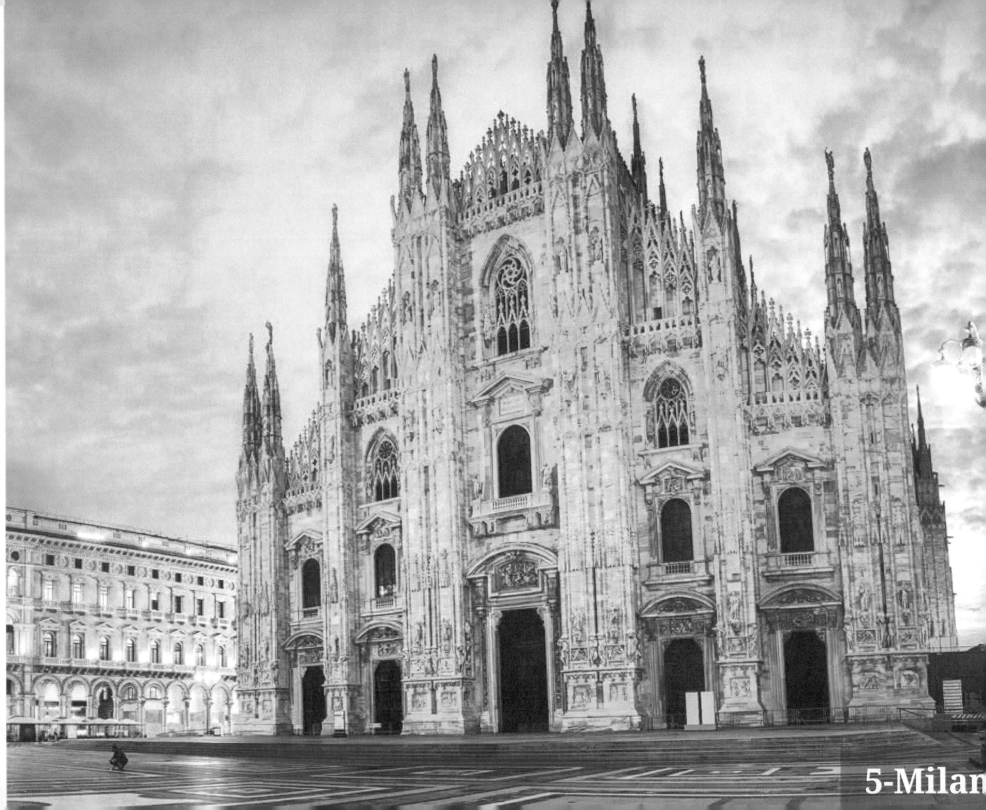

5-Milan

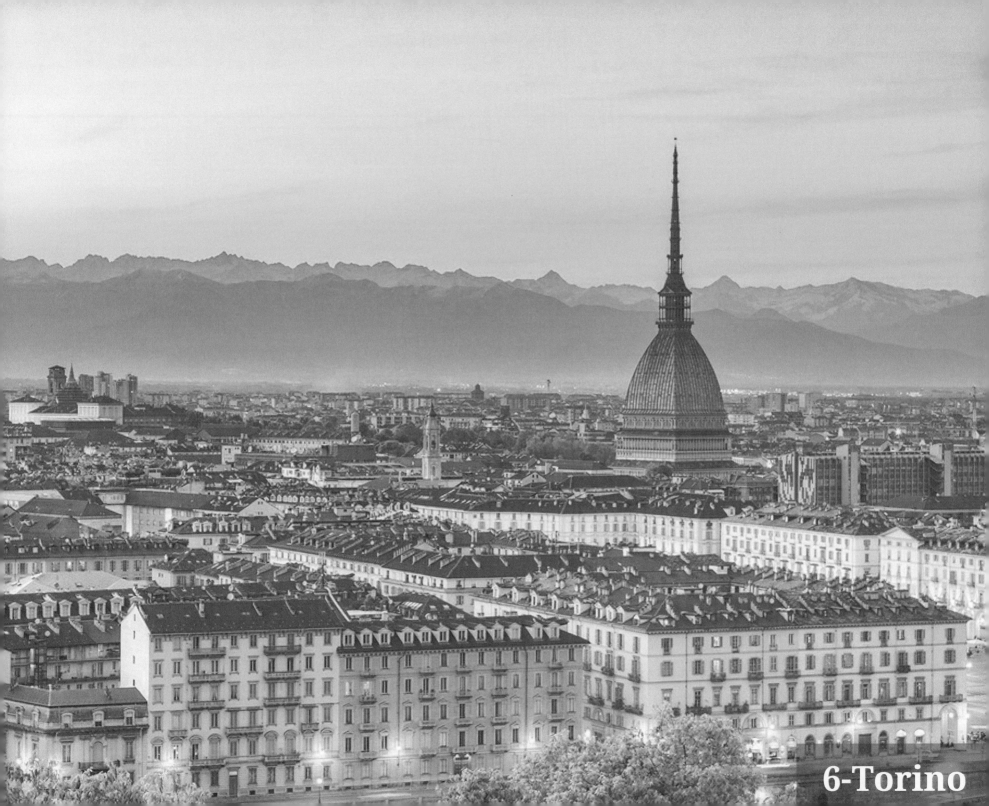

6-Torino

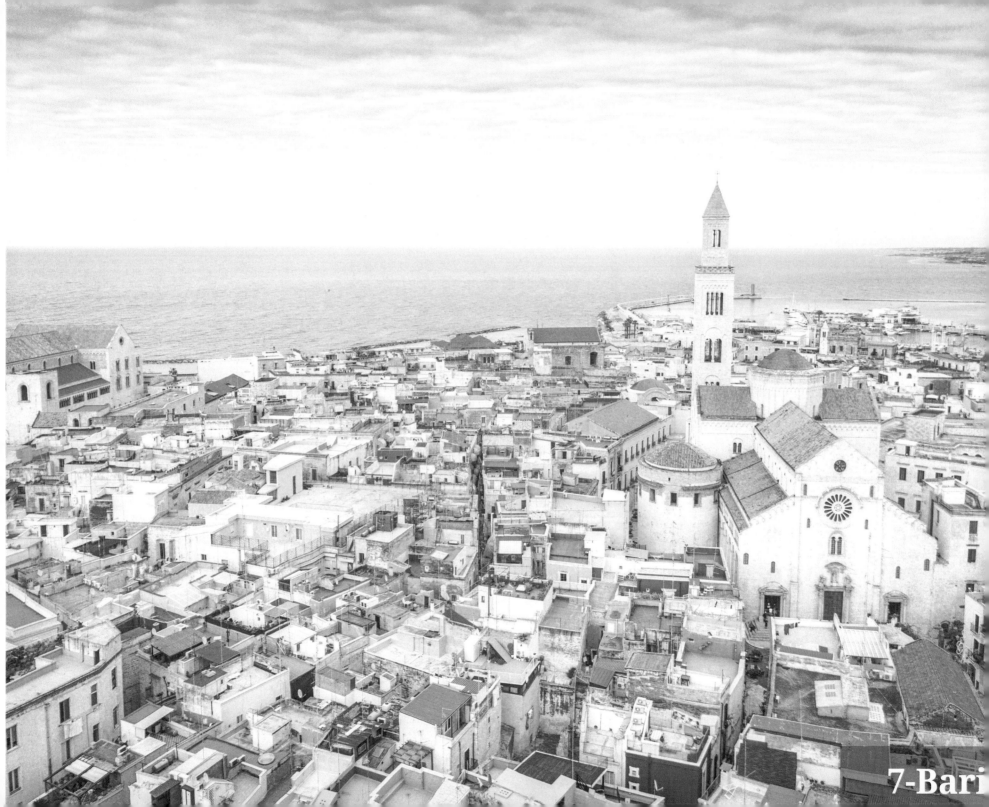

7-Bari

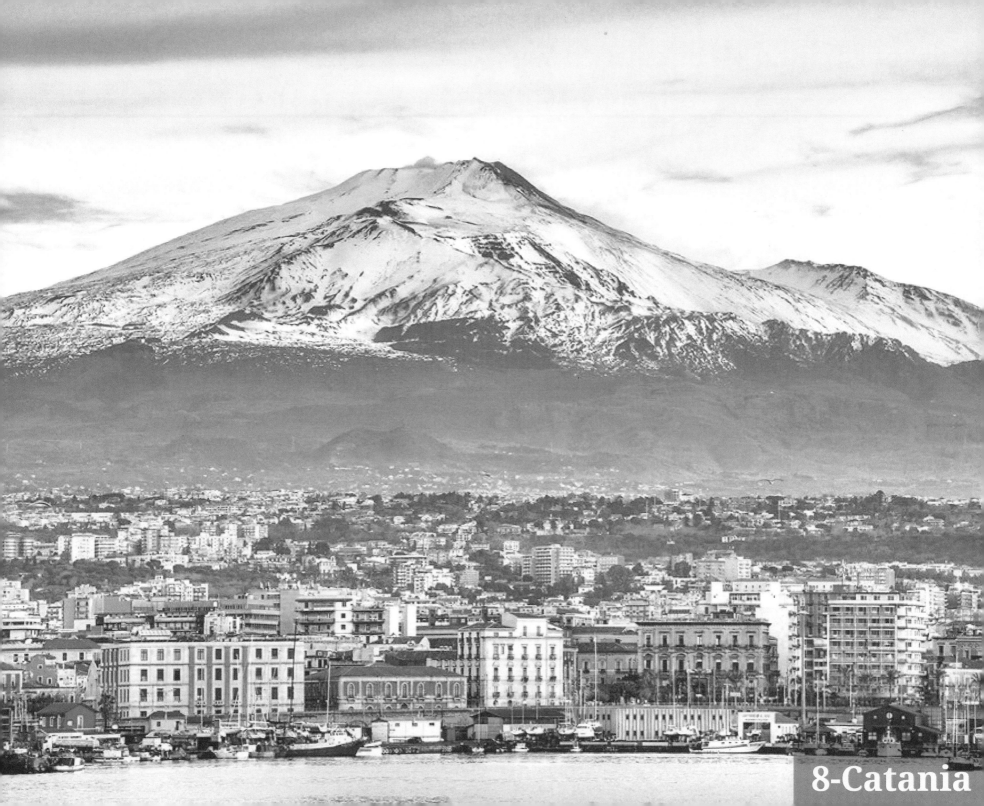

8-Catania

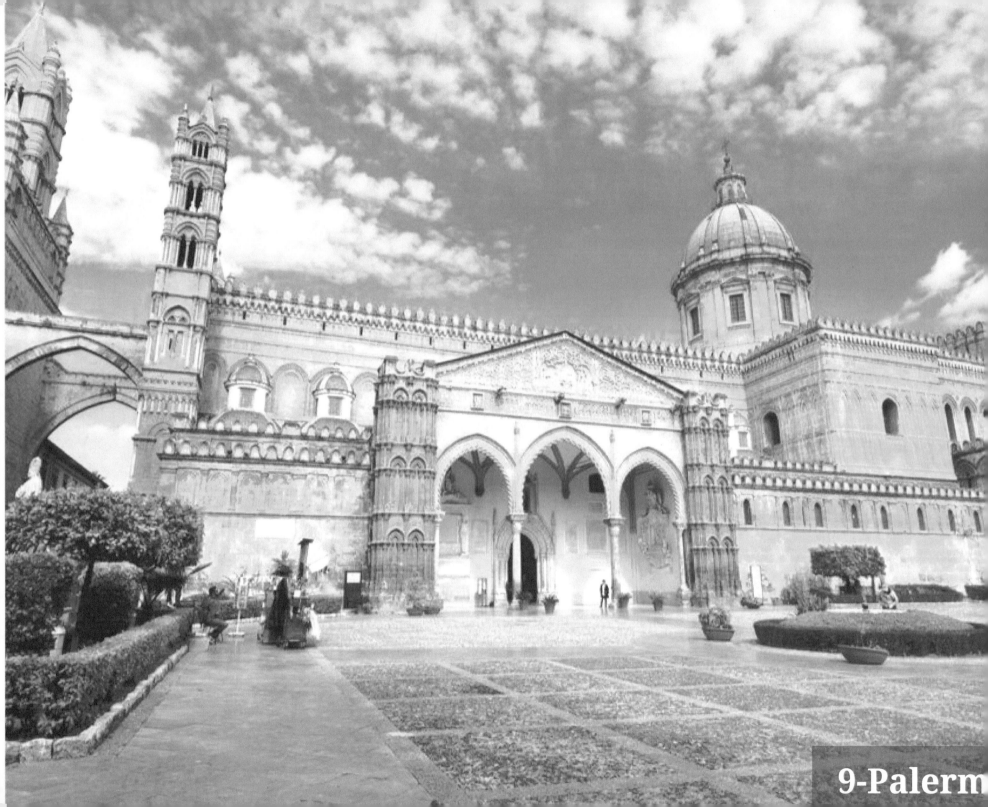

9-Palerm

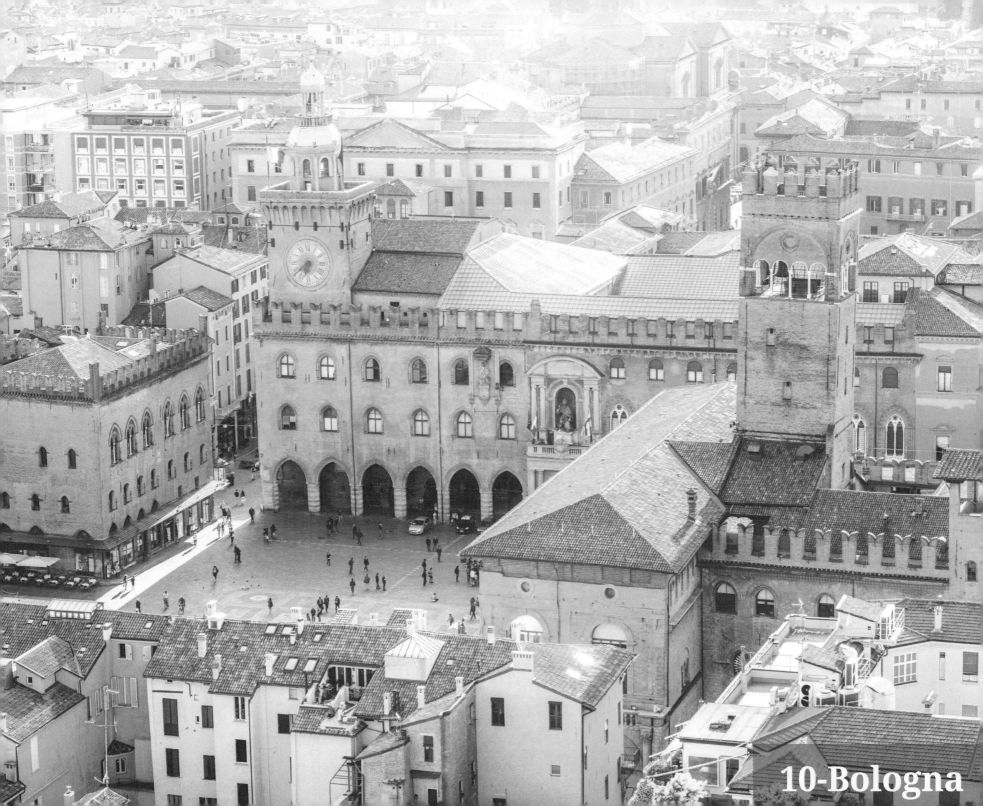
10-Bologna

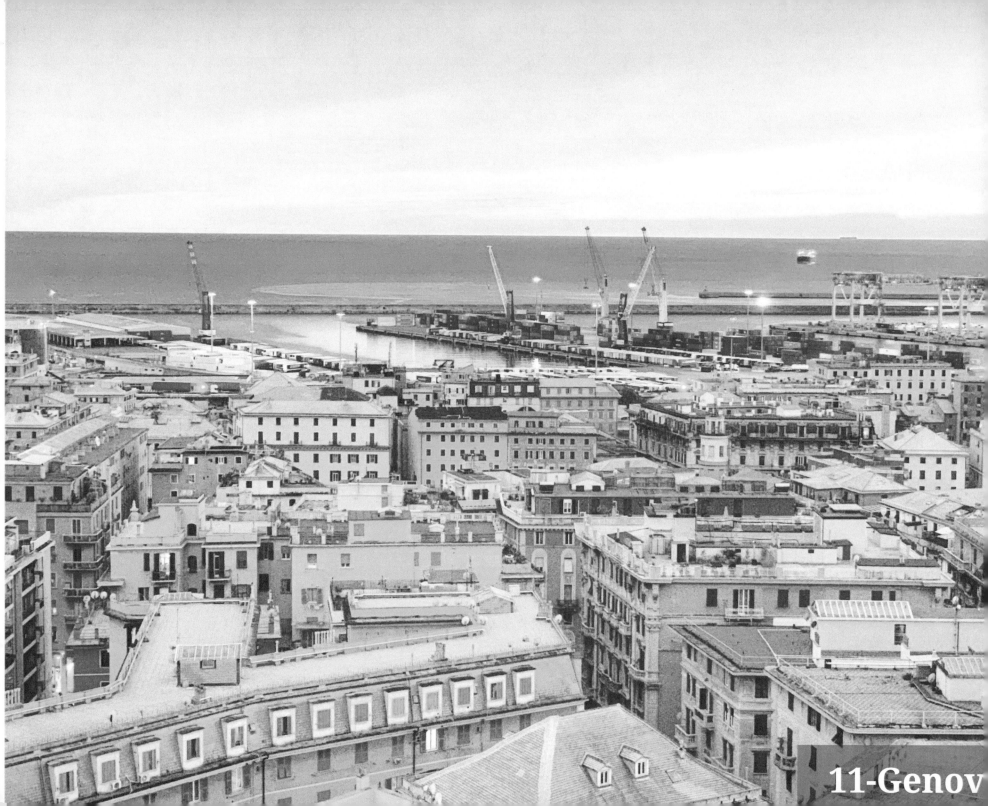

11-Genov

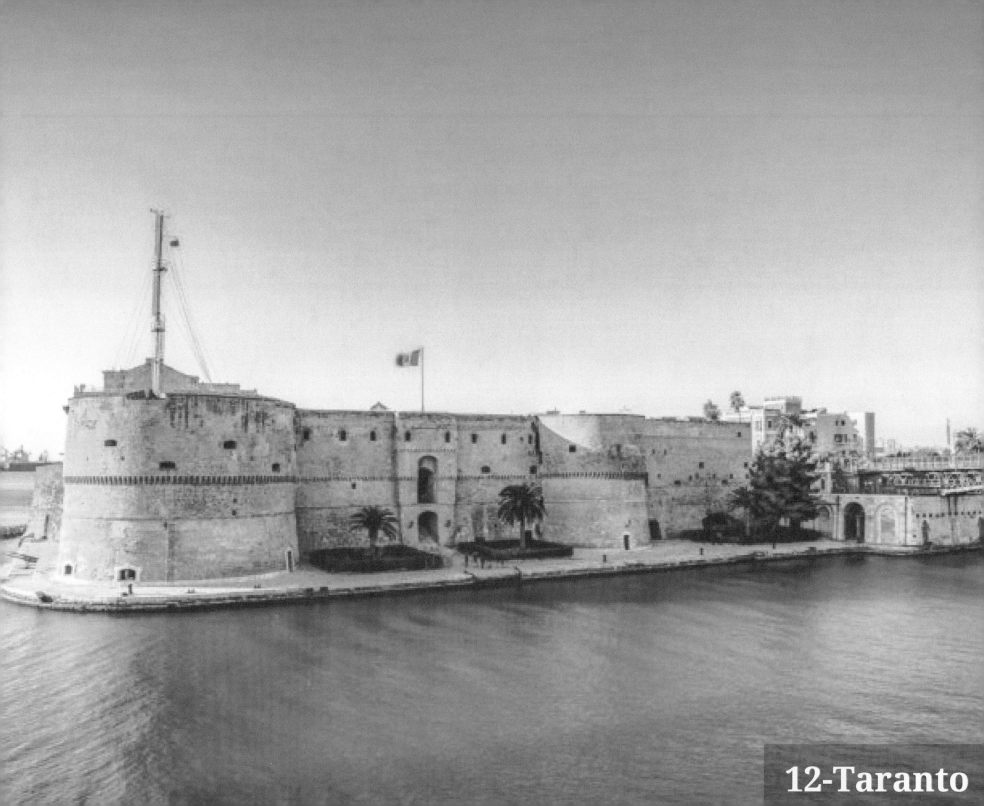

12-Taranto

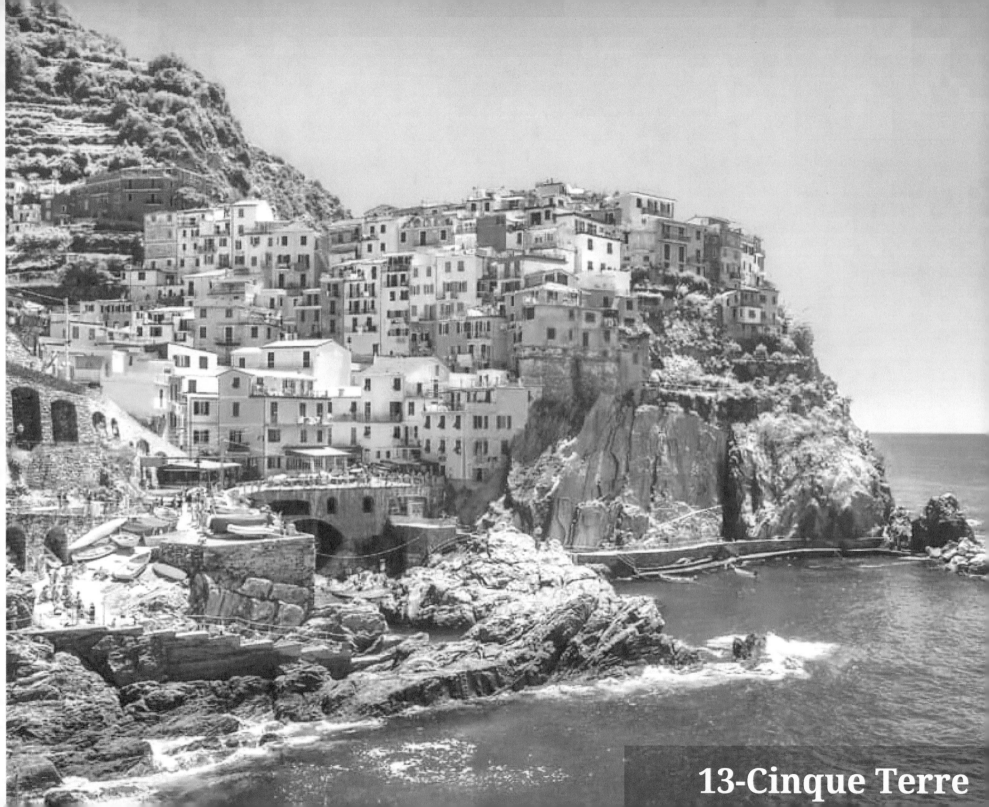

13-Cinque Terre

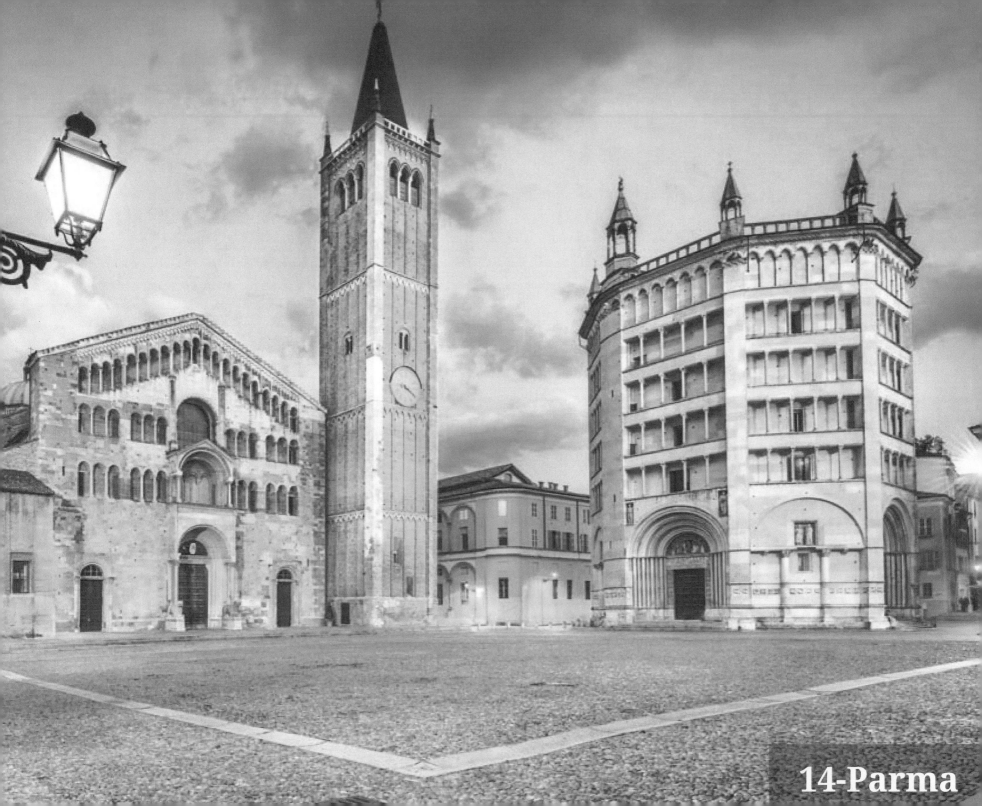

14-Parma

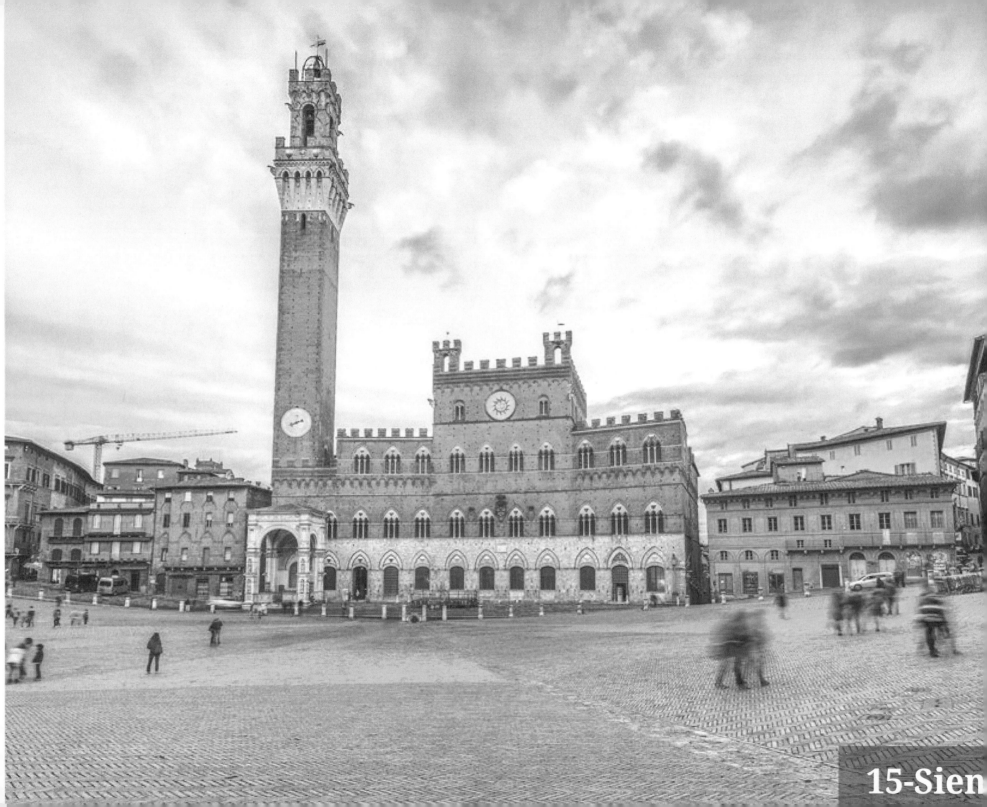

15-Sien

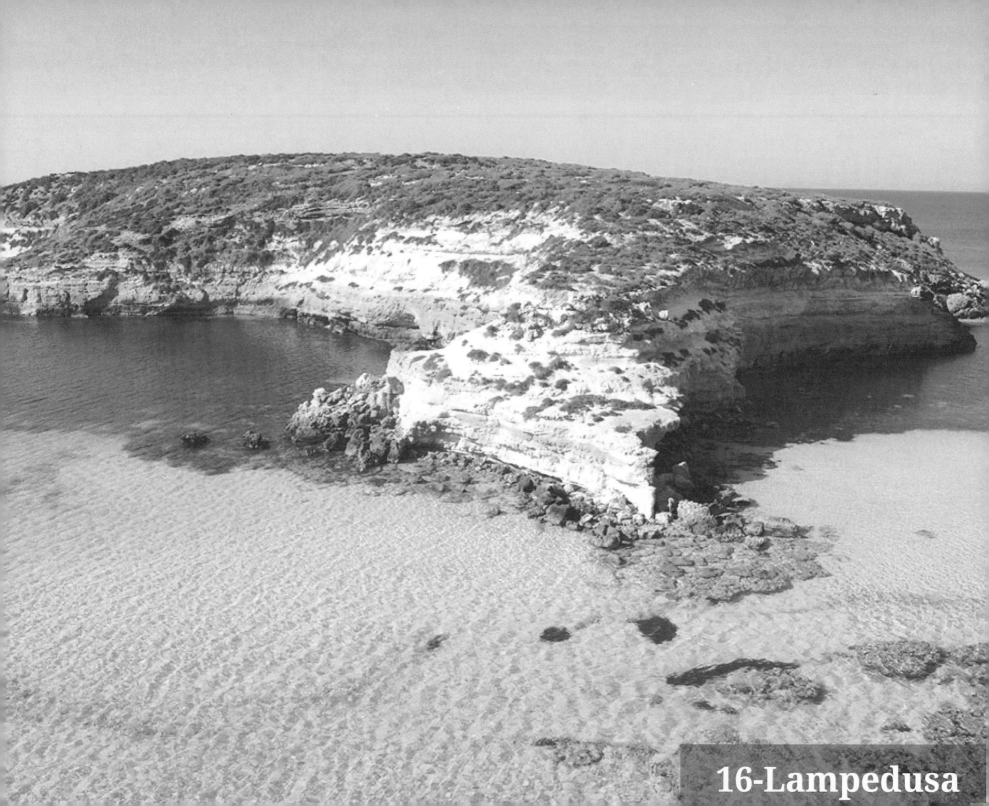

16-Lampedusa

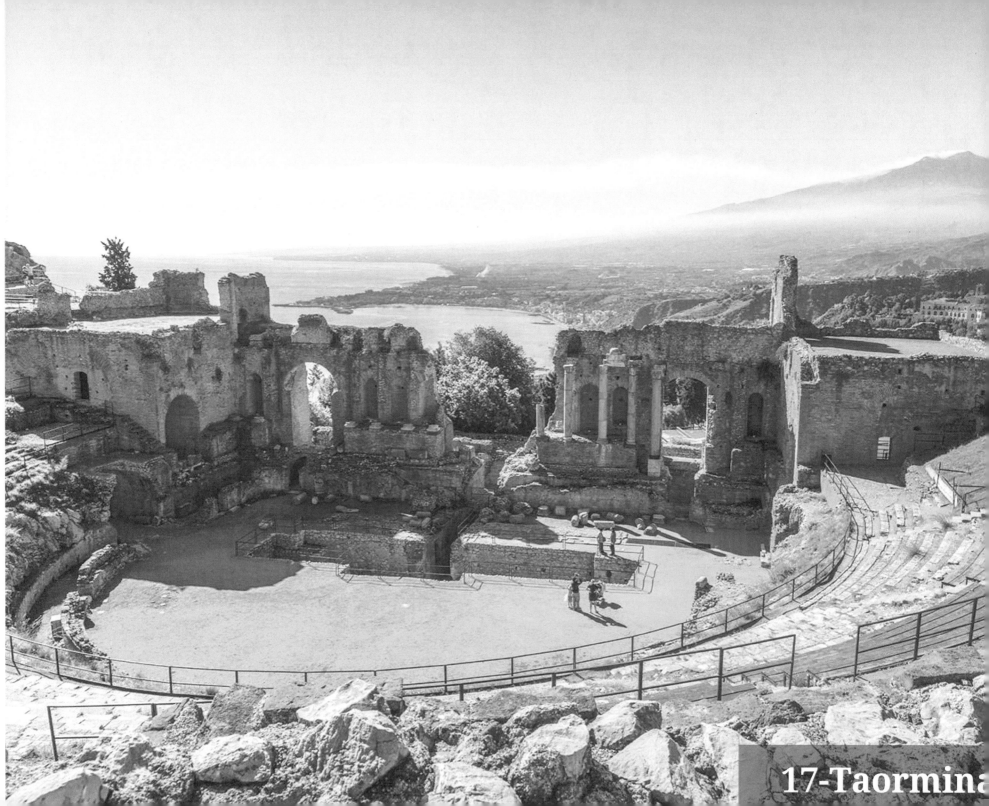

17-Taormina

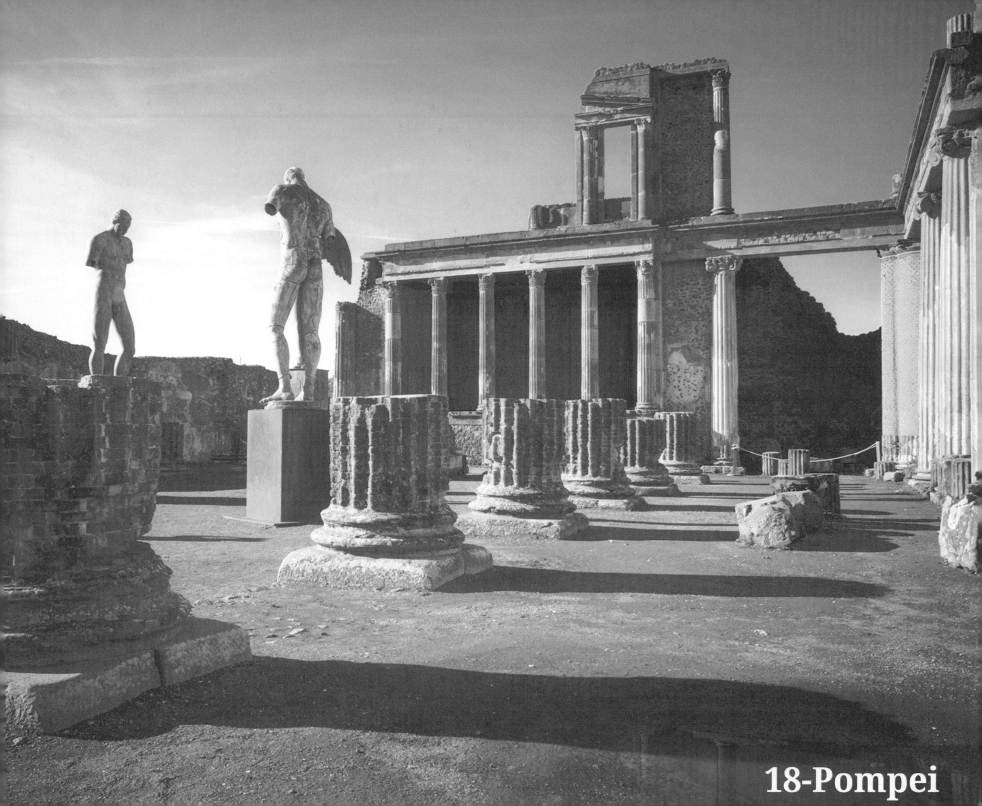

18-Pompei

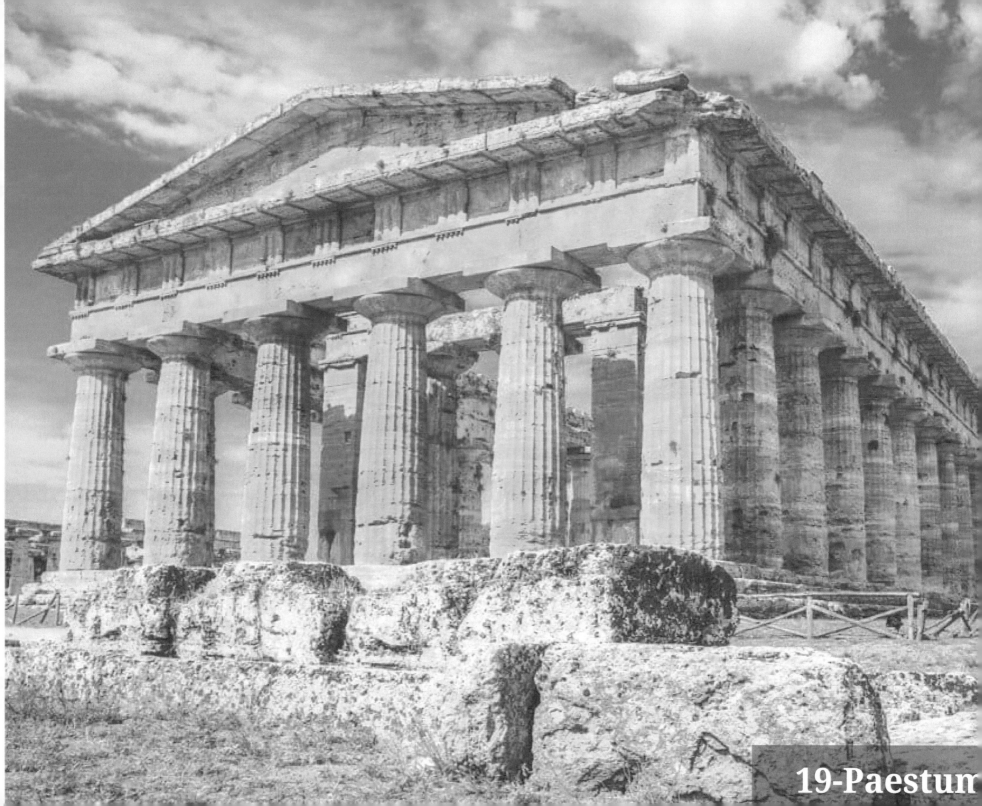

19-Paestum

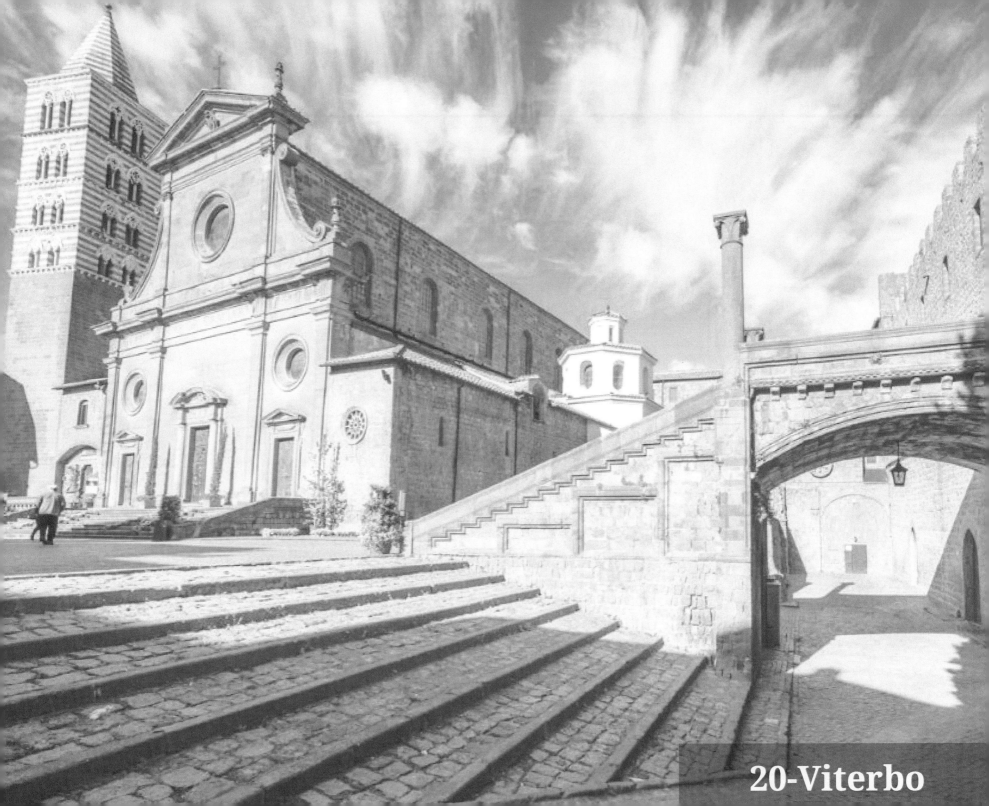

20-Viterbo

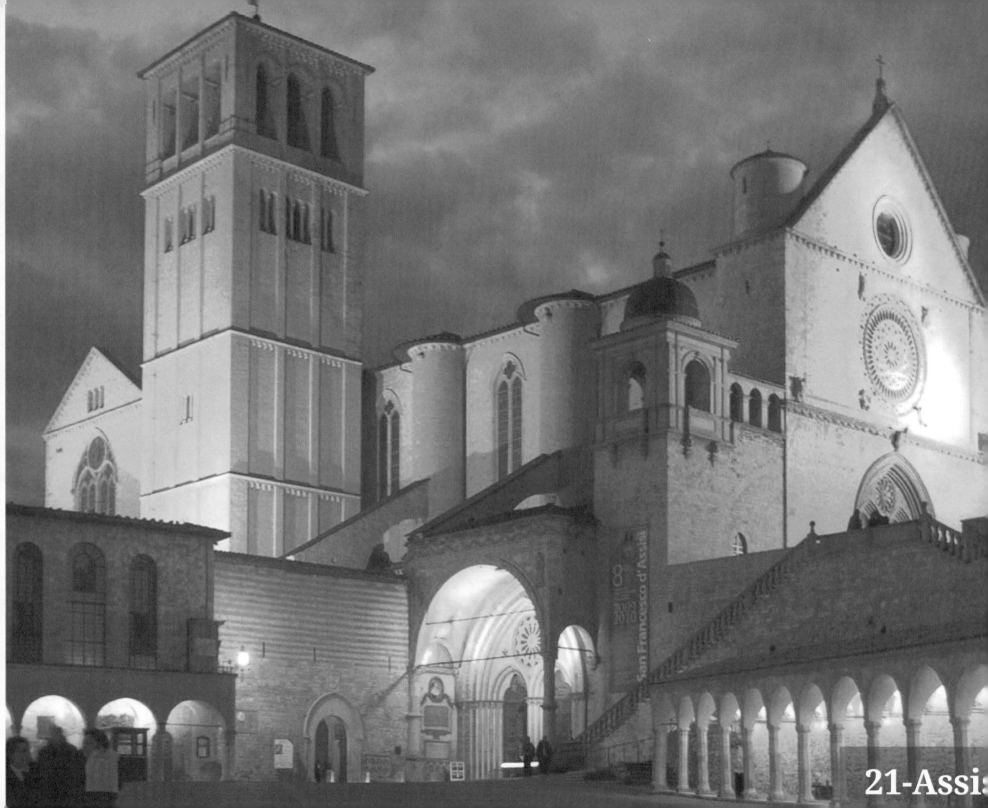

21-Assi

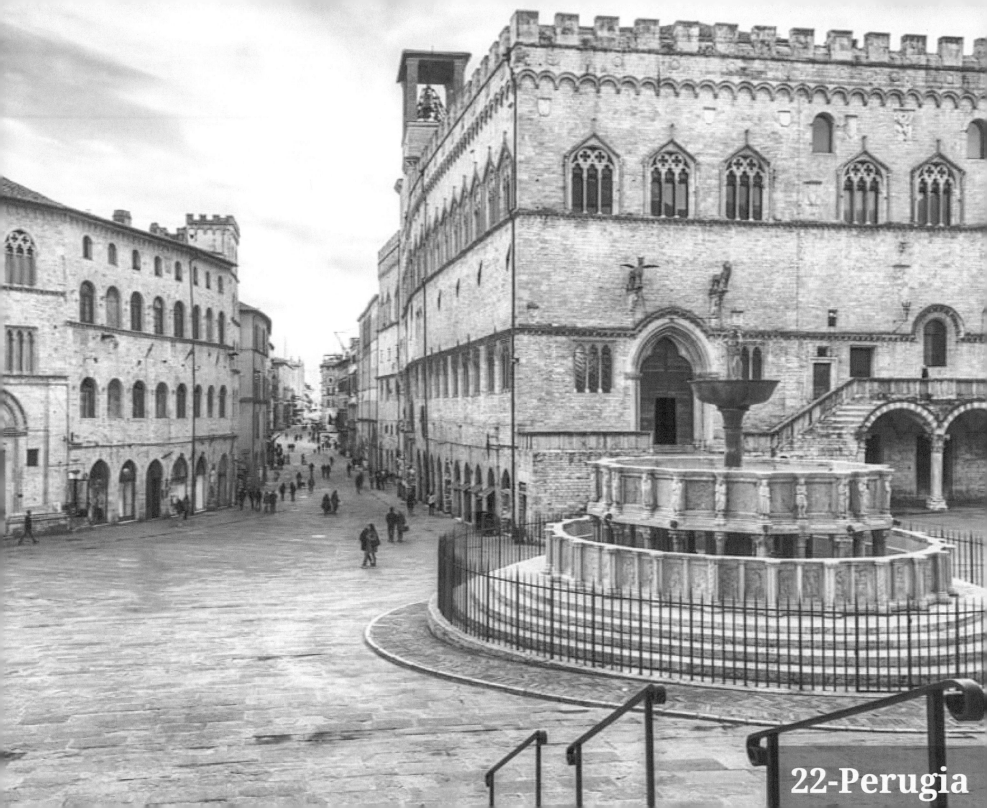

22-Perugia

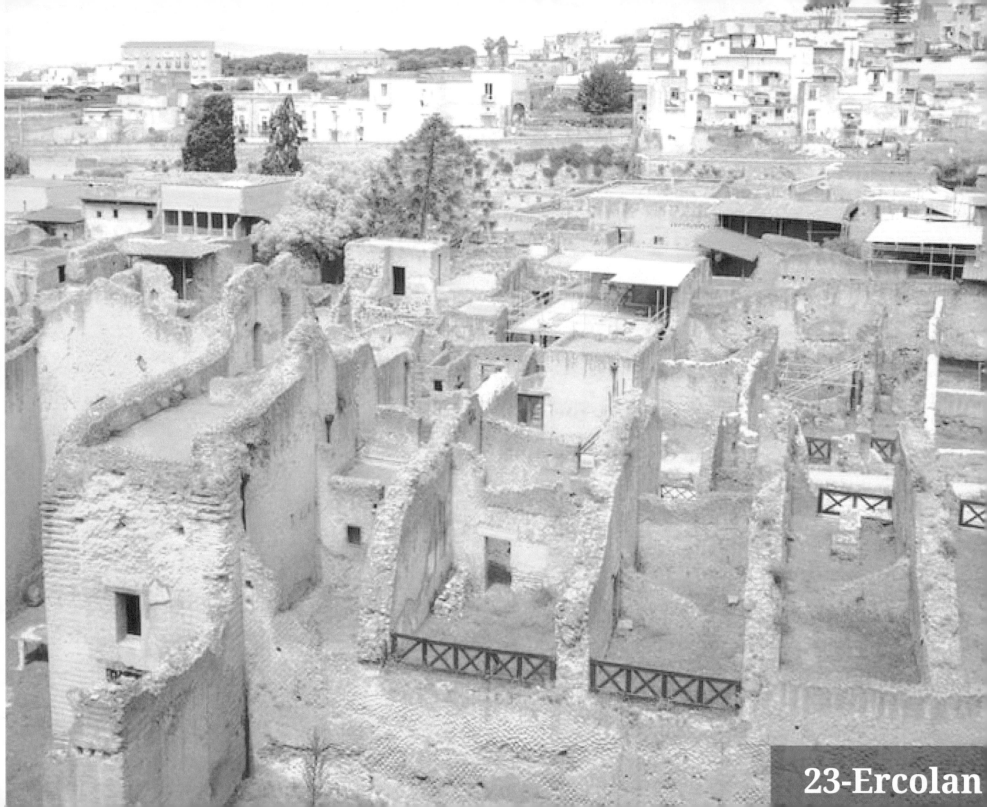

23-Ercolan

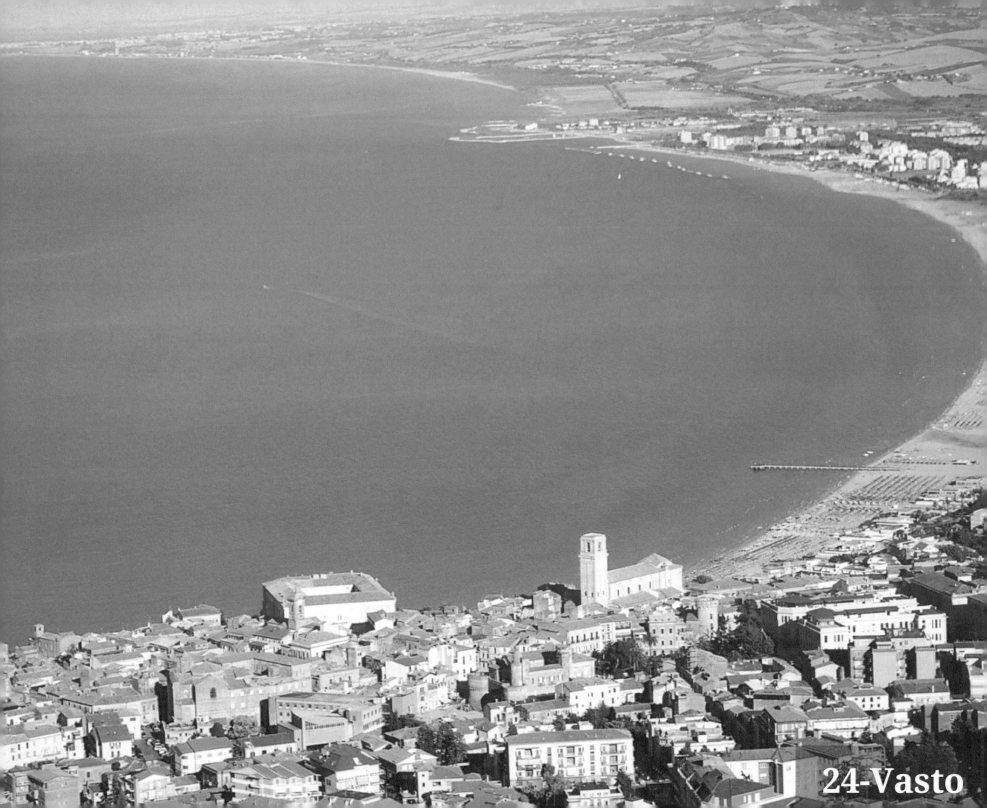

24-Vasto

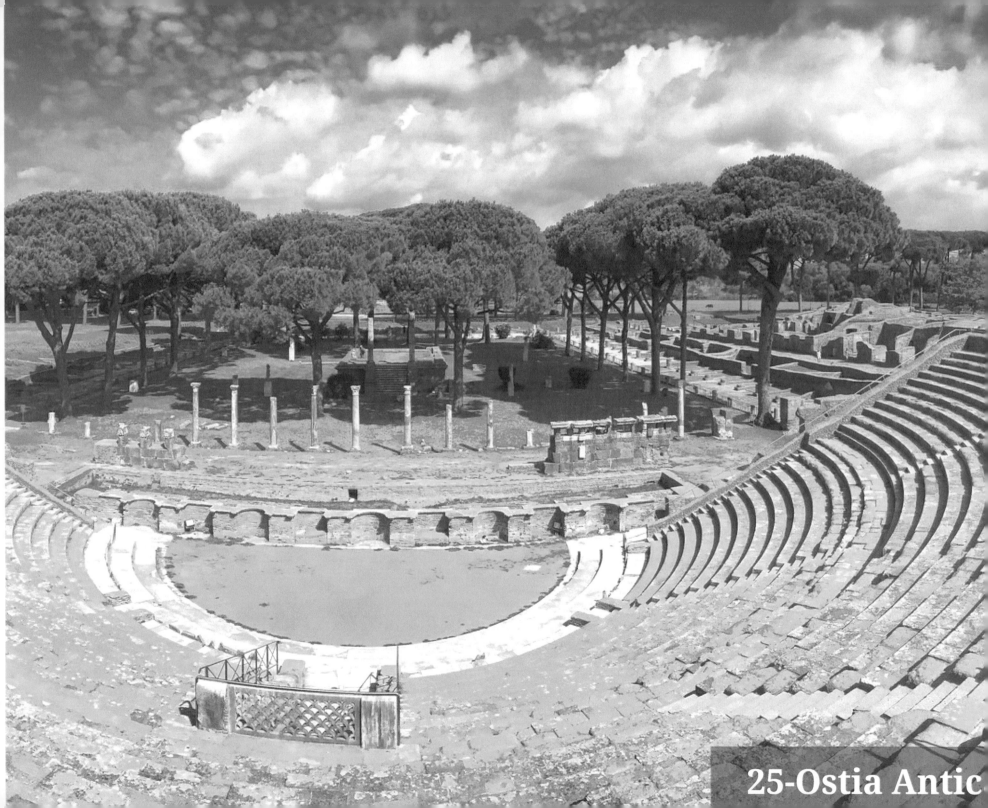

25-Ostia Antic

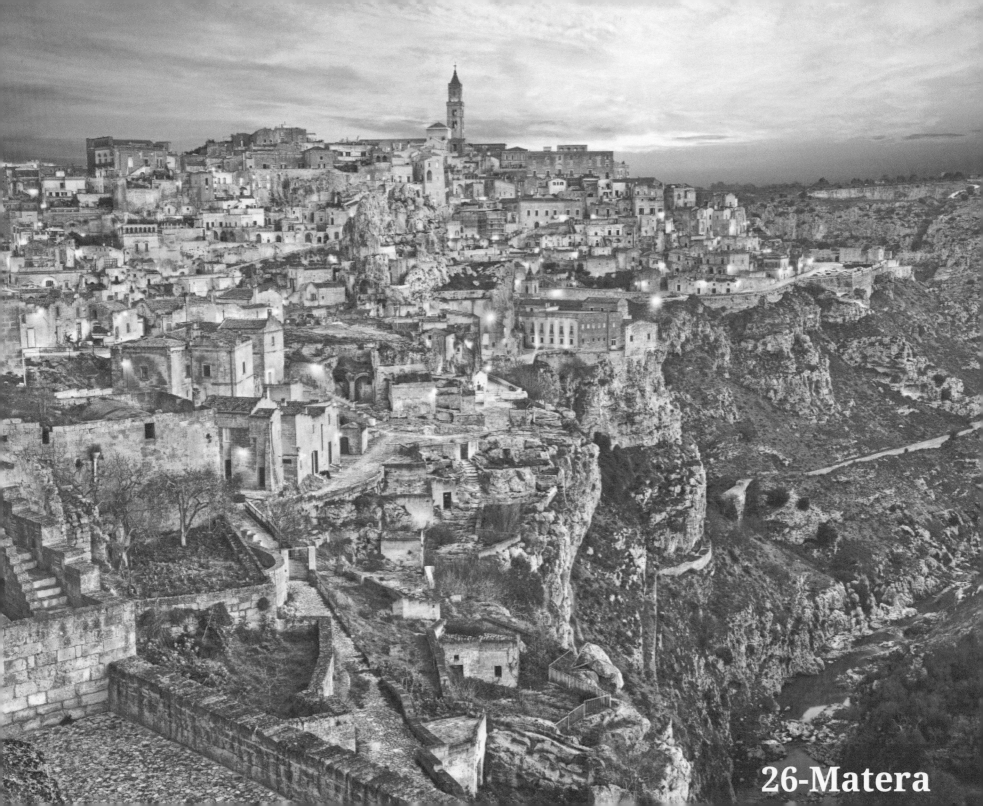

26-Matera

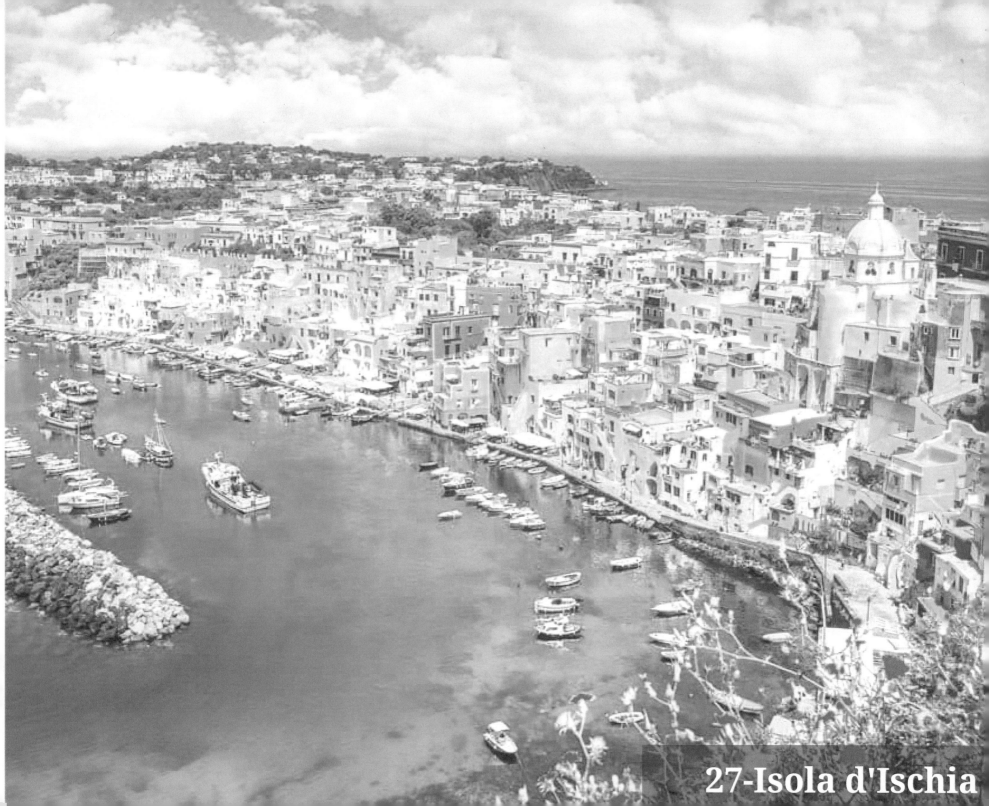

27-Isola d'Ischia

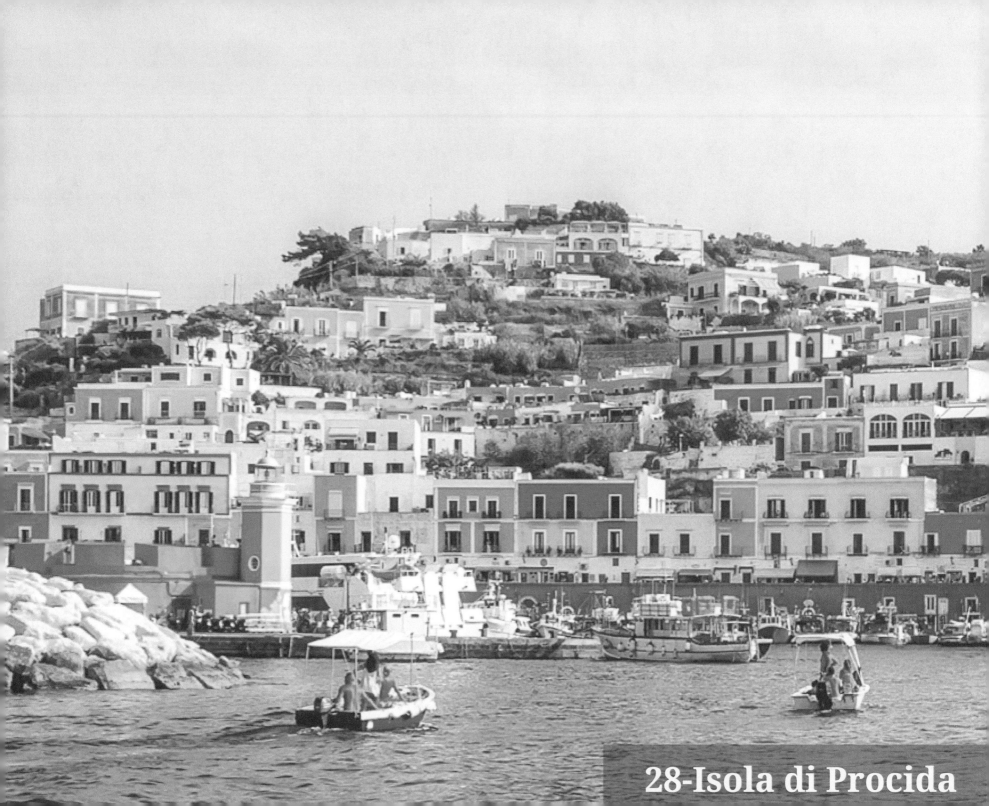

28-Isola di Procida

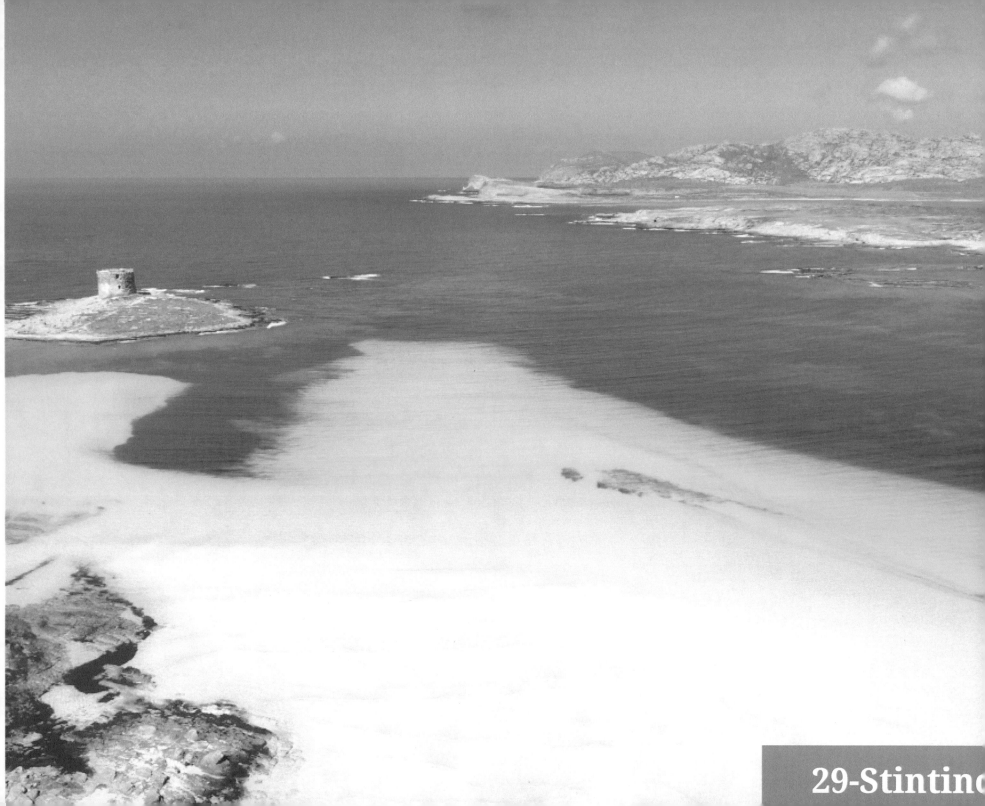

29-Stintino

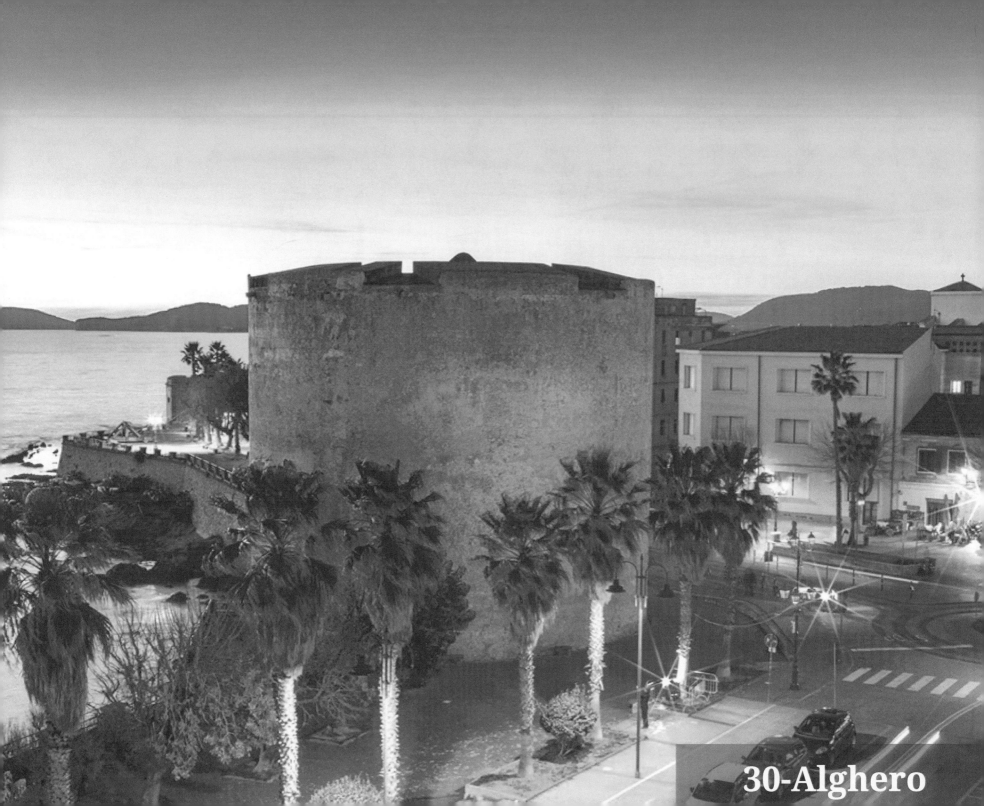

30-Alghero

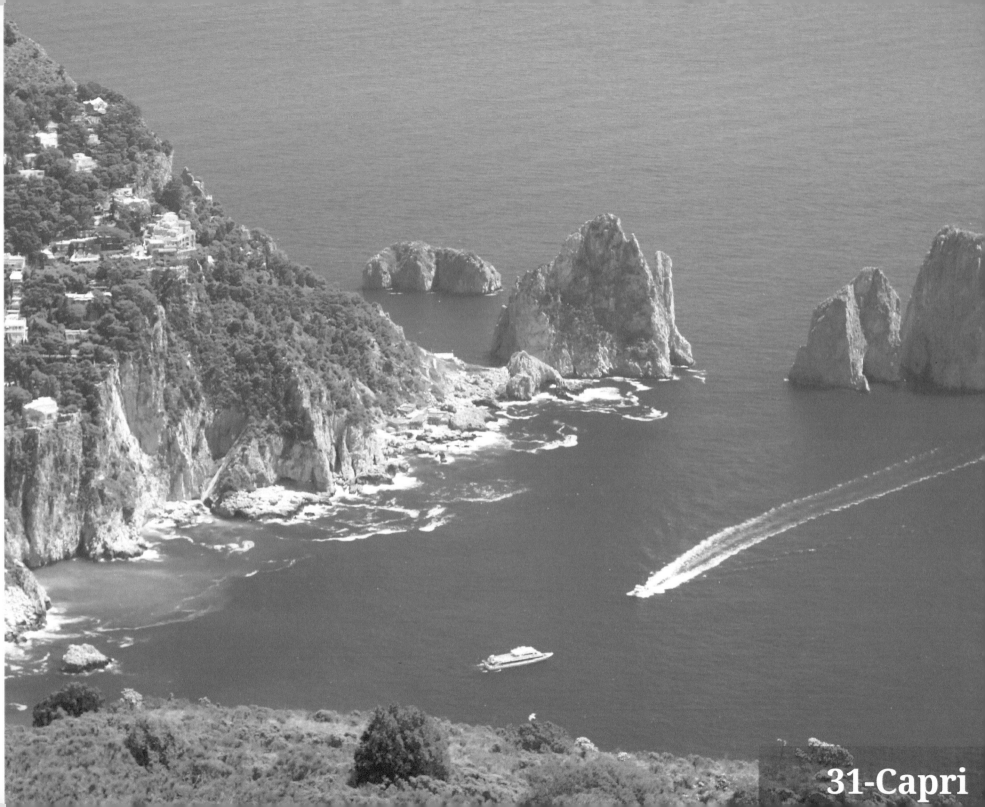

31-Capri

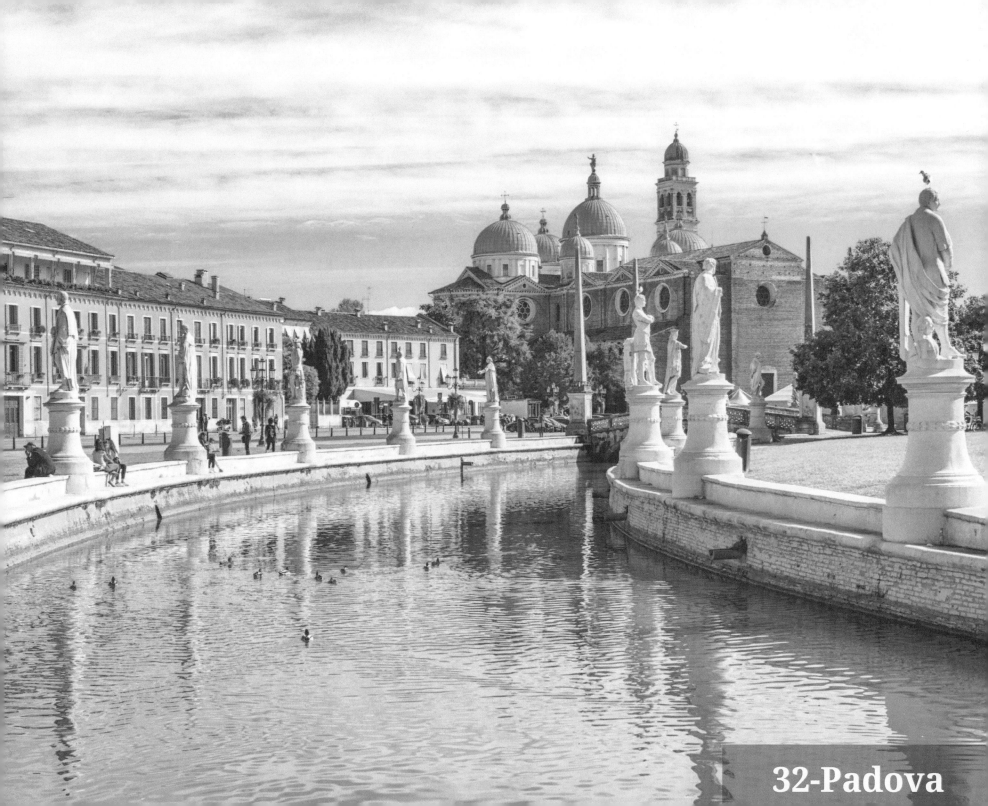

32-Padova

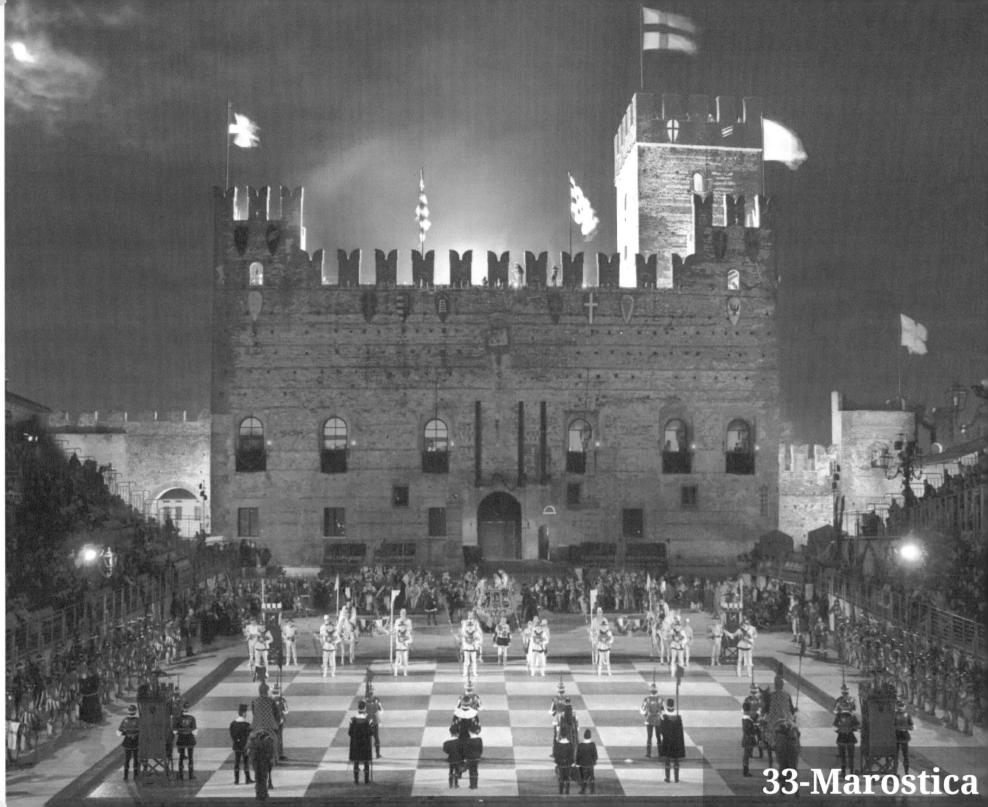

33-Marostica

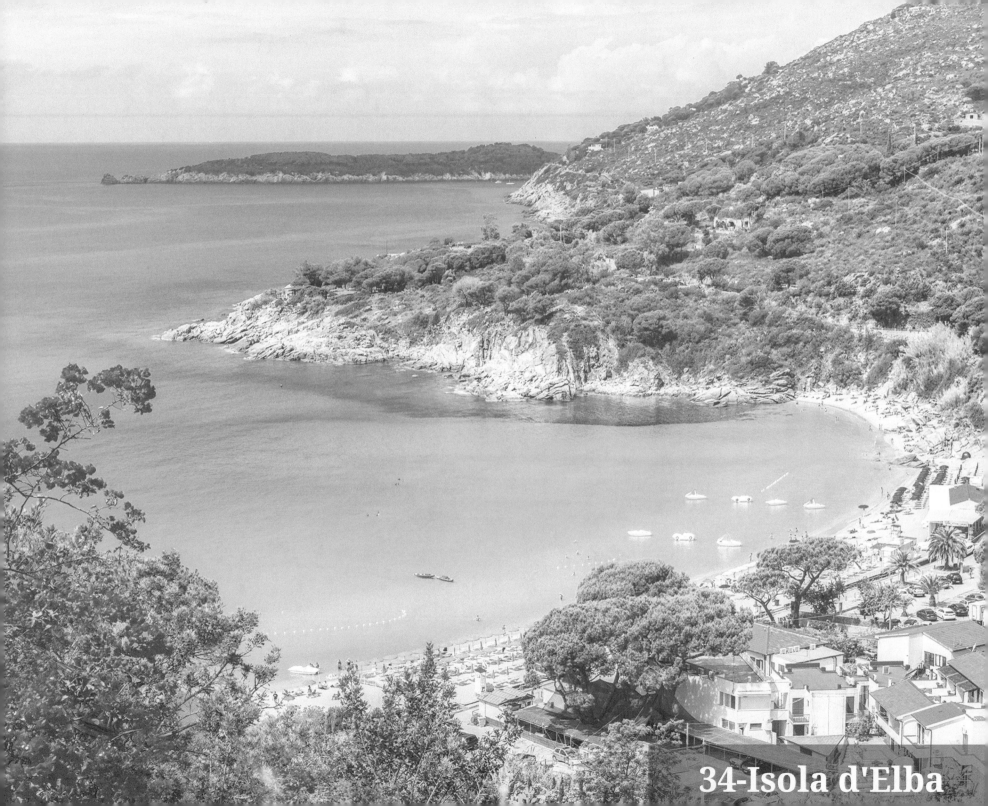

34-Isola d'Elba

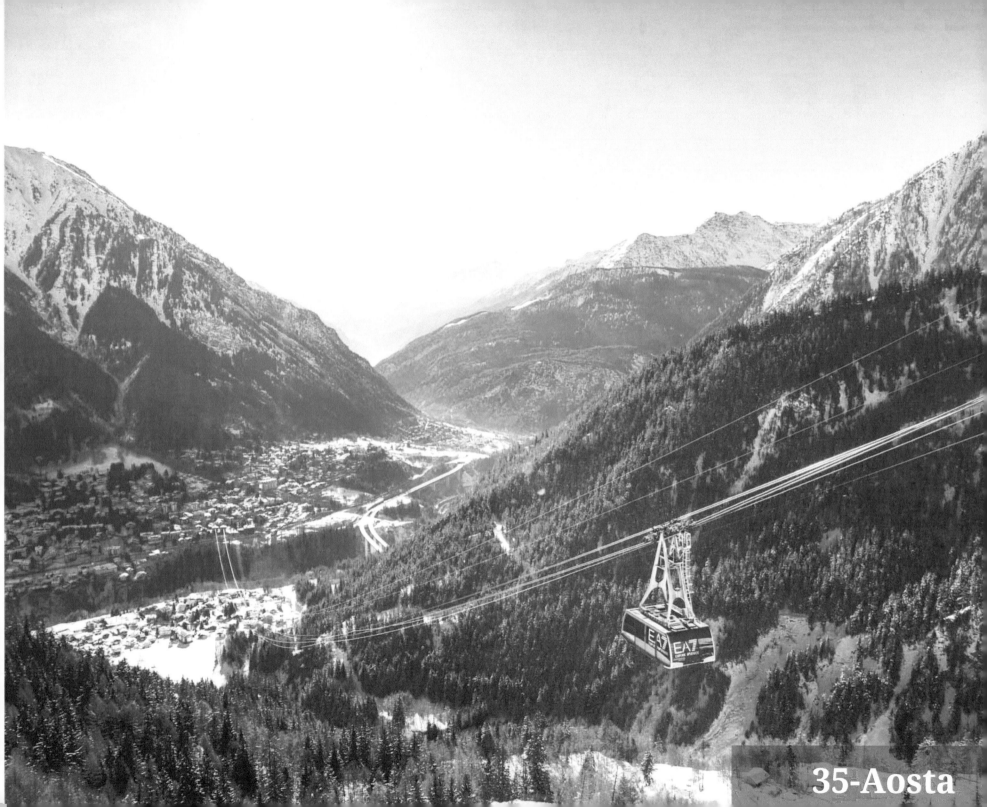

35-Aosta

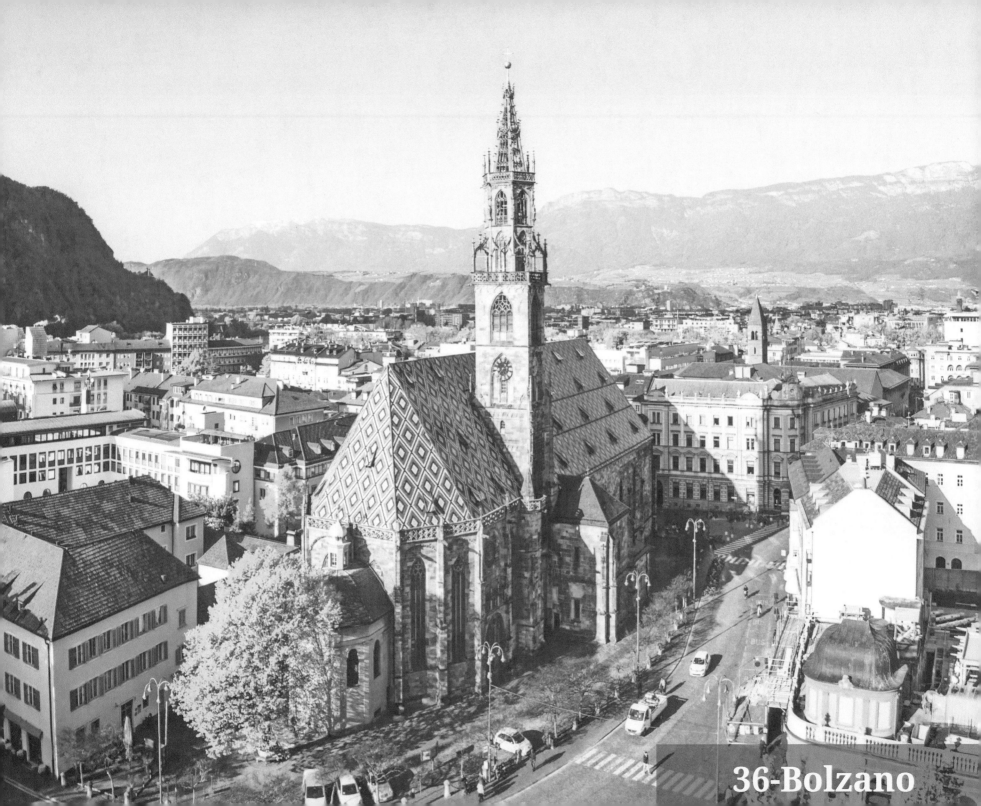

36-Bolzano

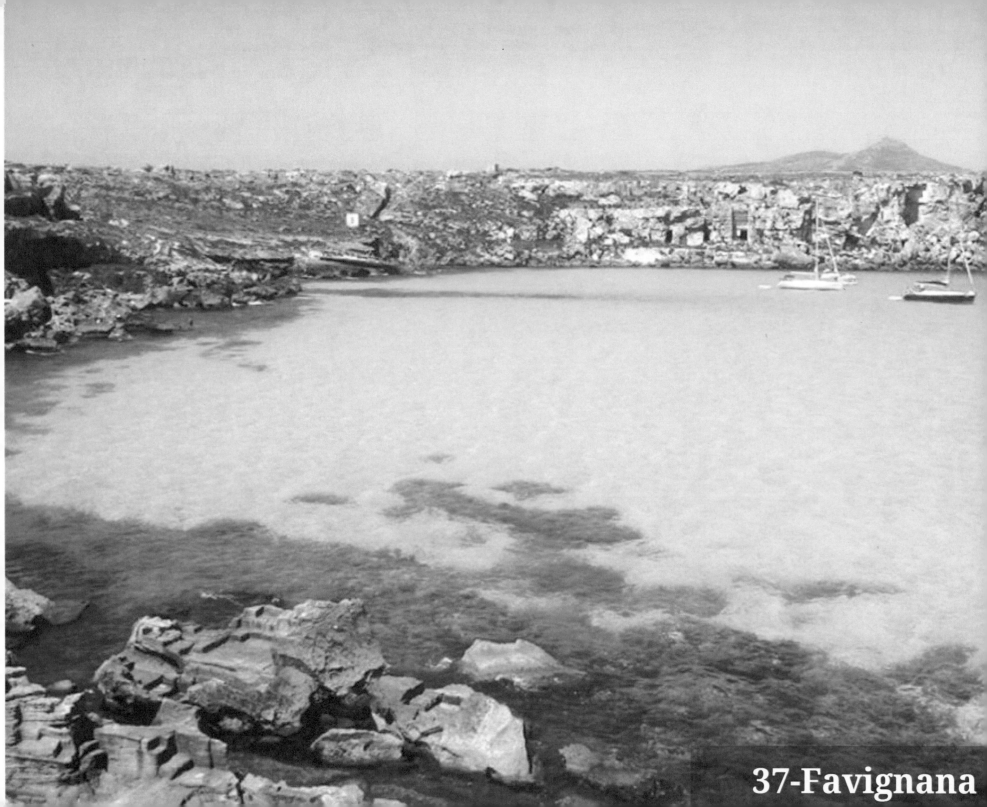

37-Favignana

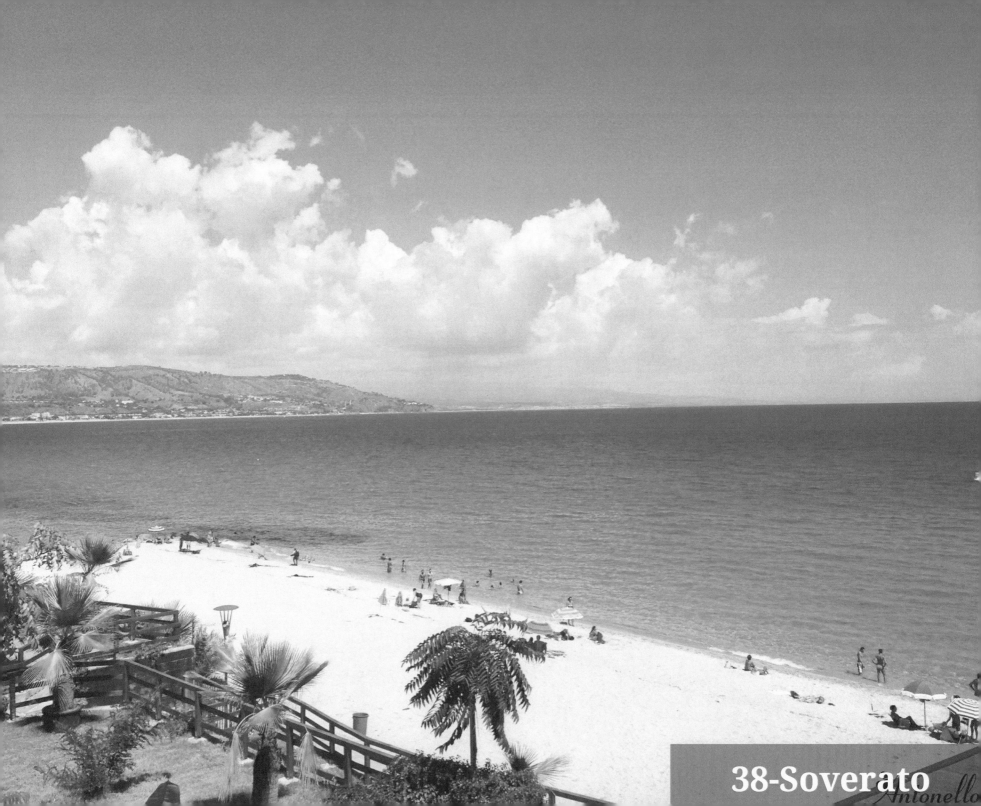

38-Soverato

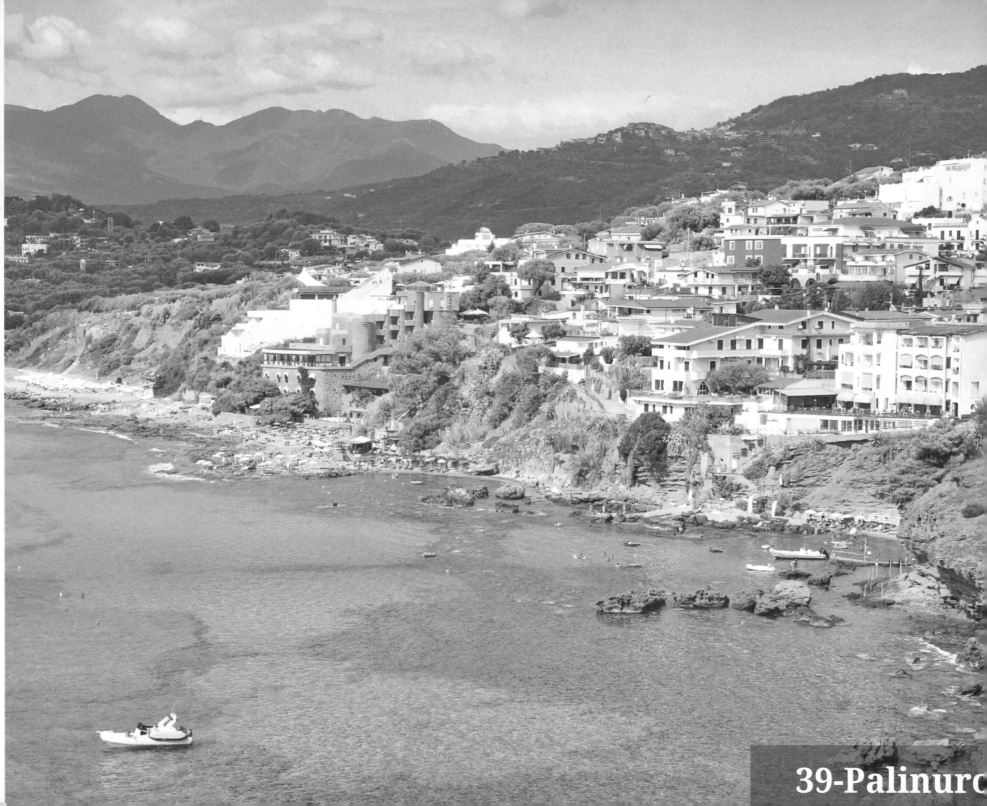

39-Palinuro

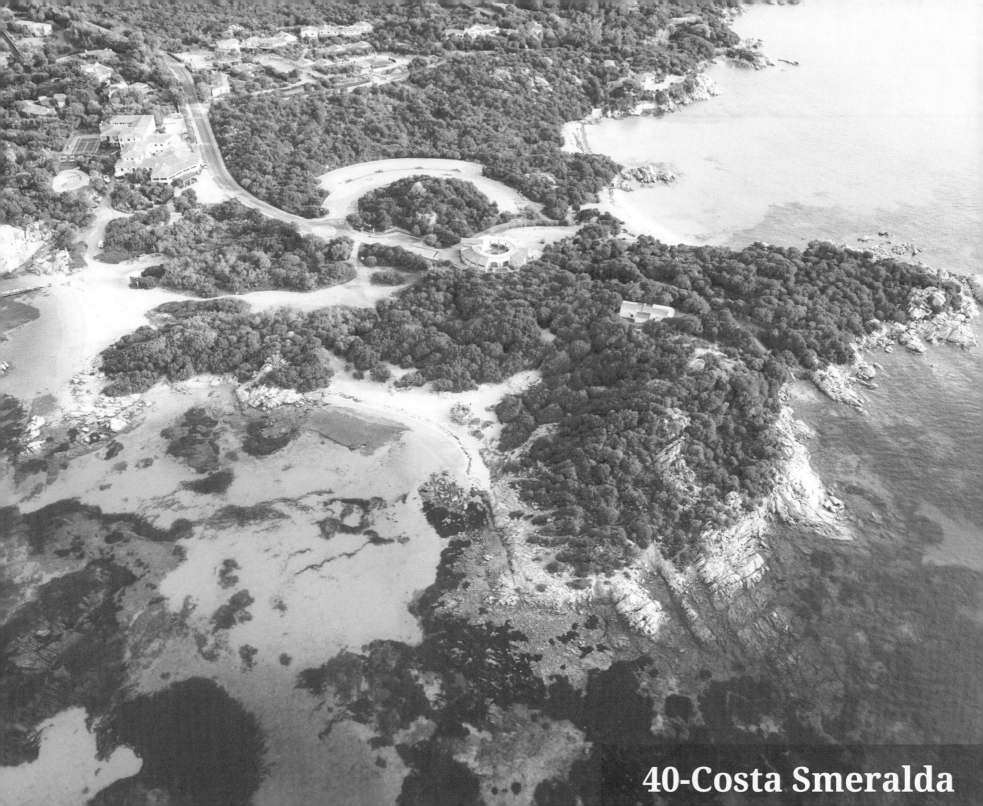

40-Costa Smeralda

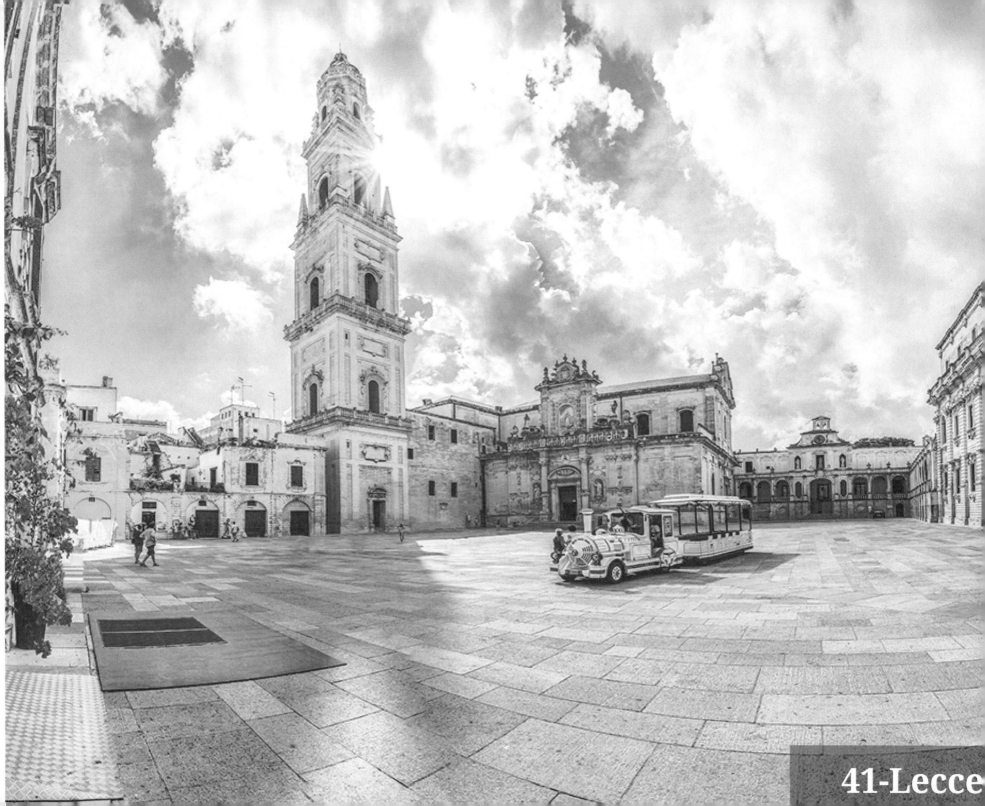

41-Lecce

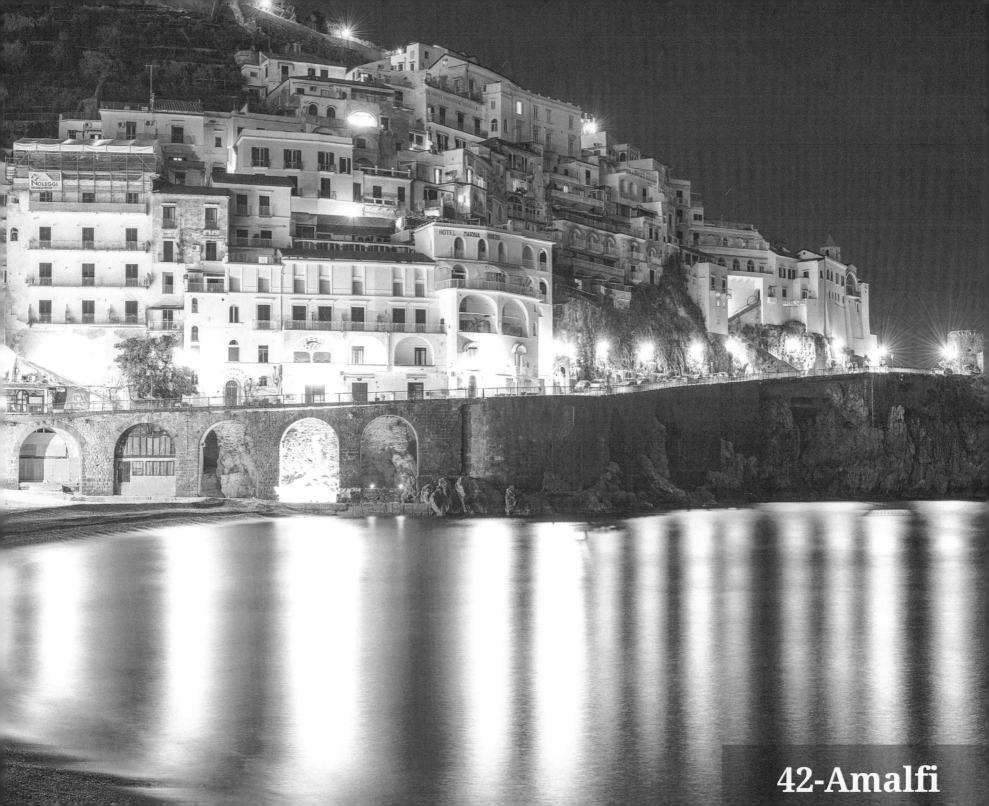

42-Amalfi

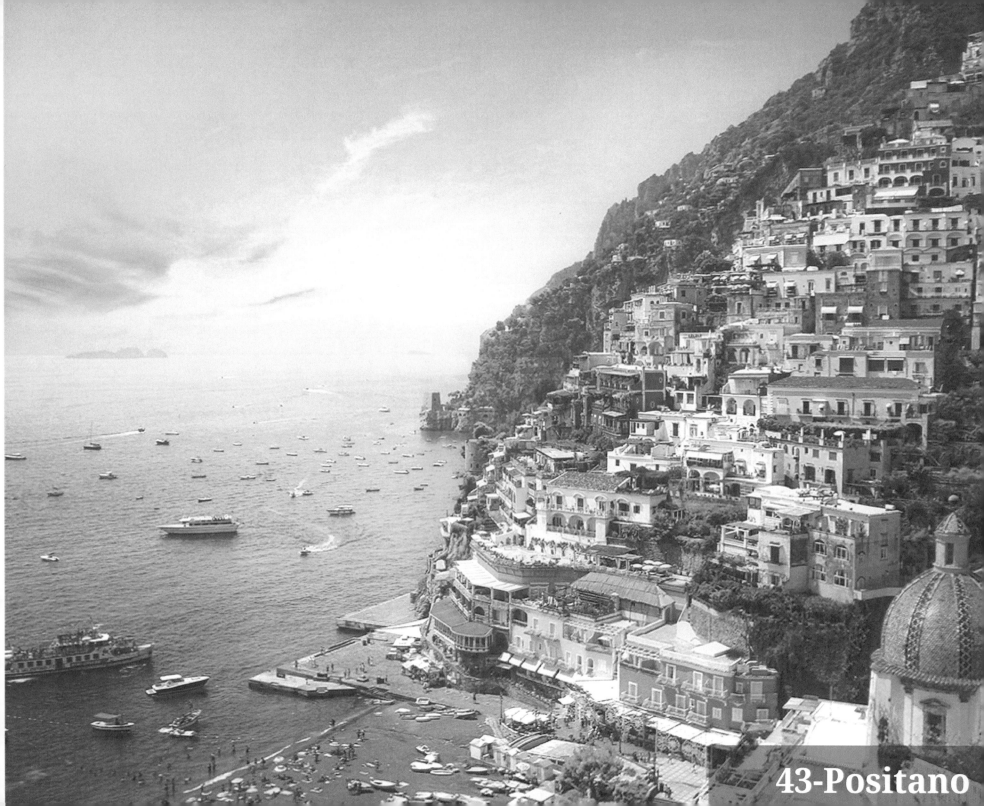

43-Positano

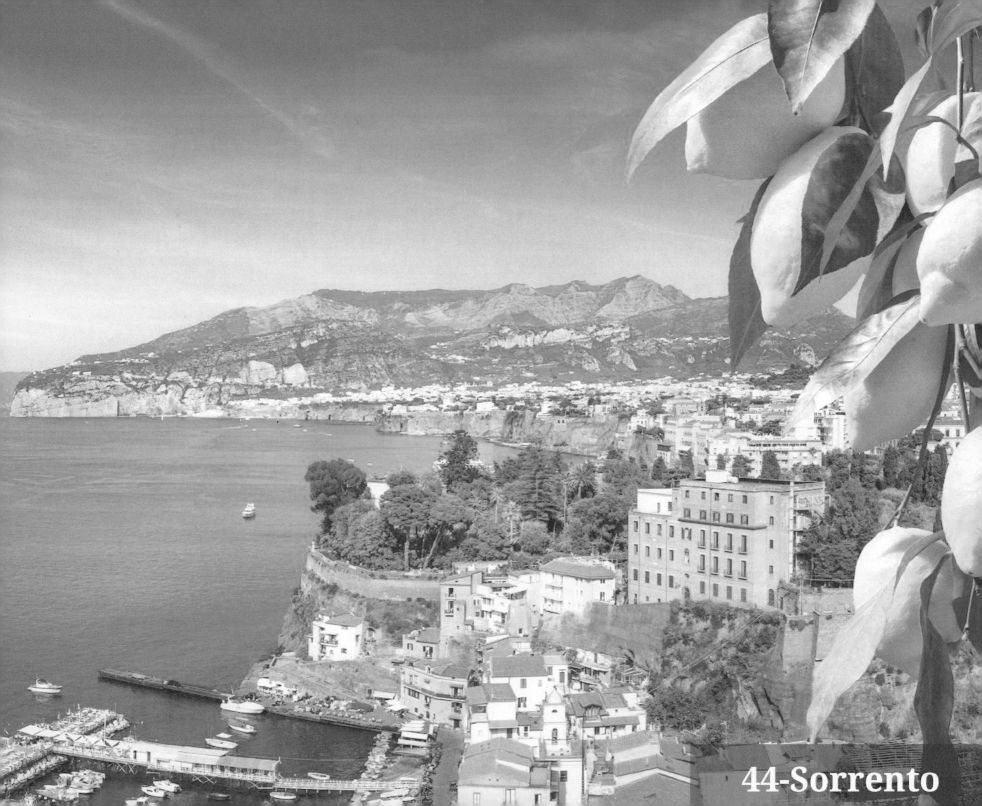

44-Sorrento

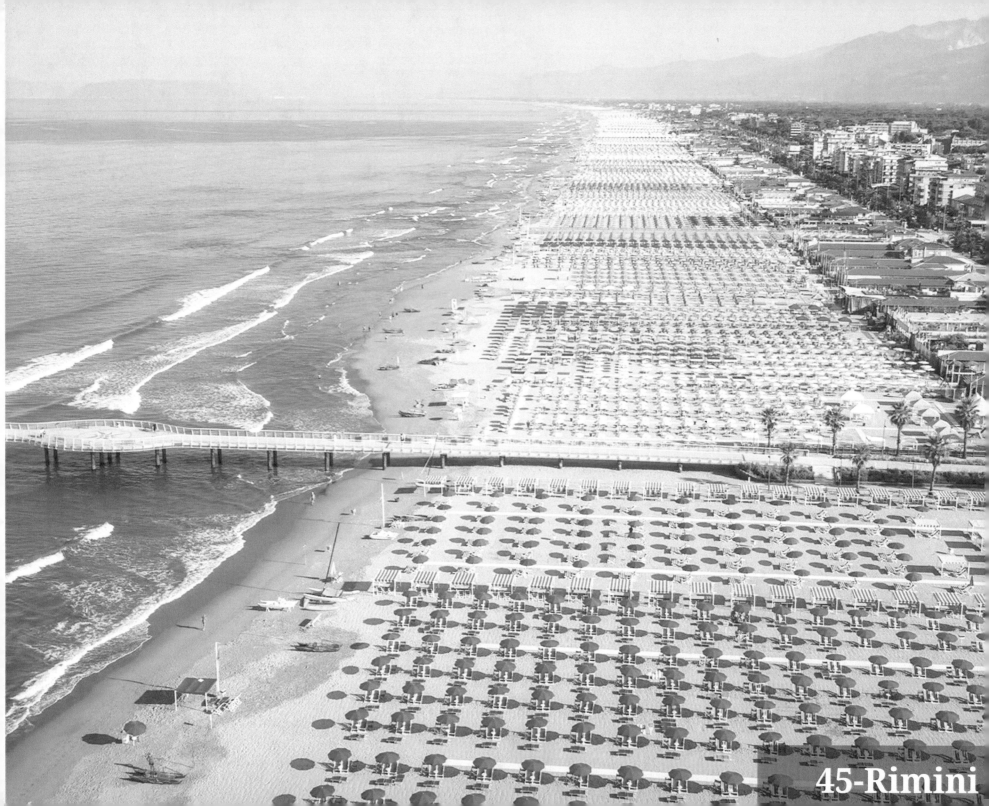

45-Rimini

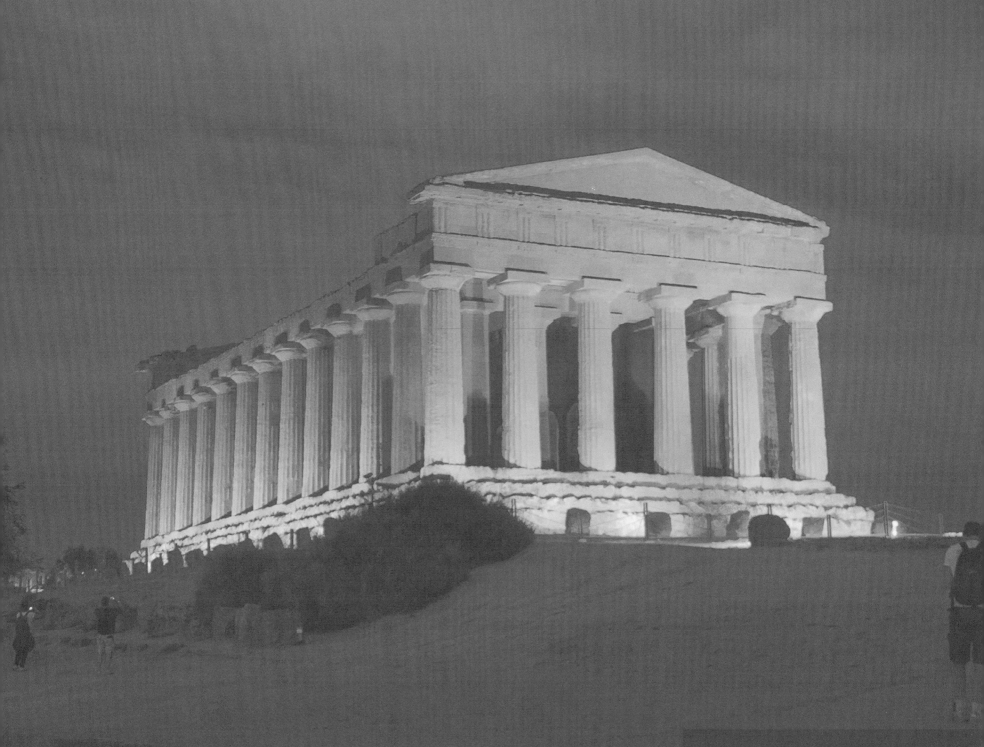

46-Agrigento

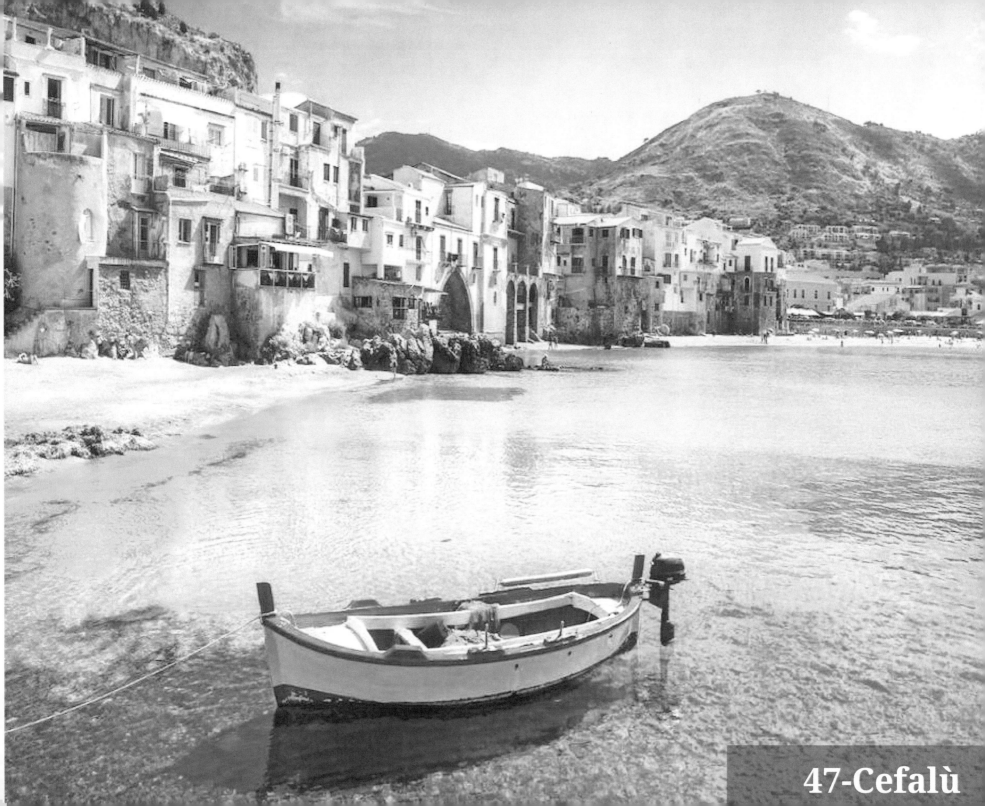

47-Cefalù

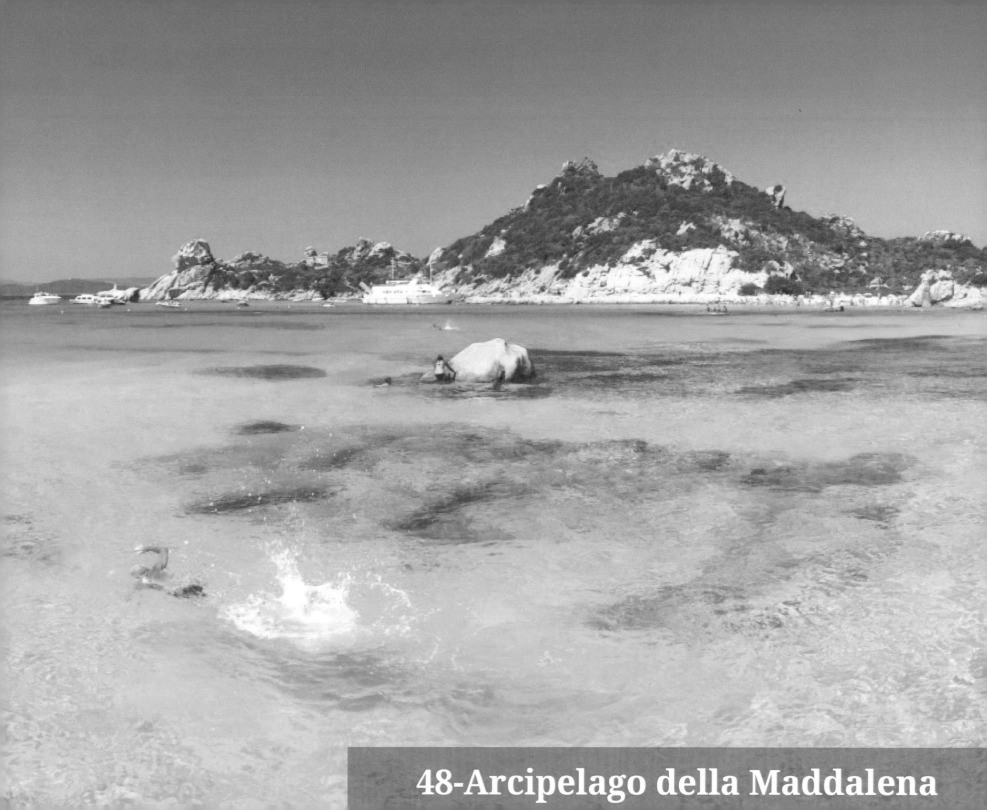

48-Arcipelago della Maddalena

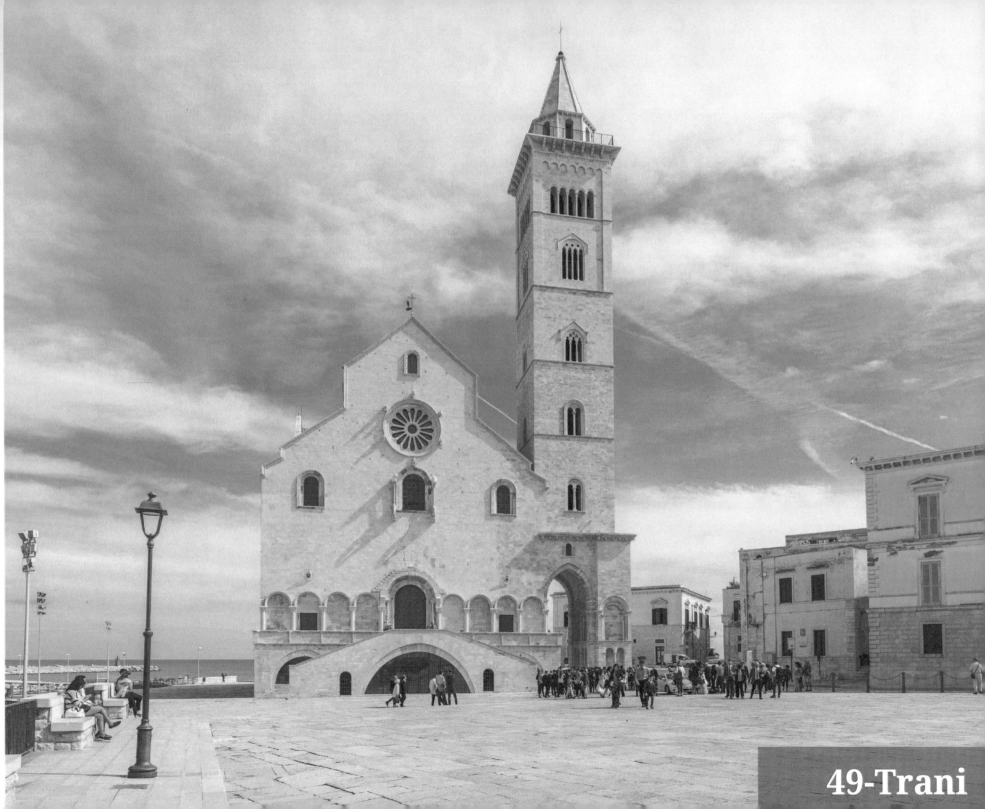

49-Trani

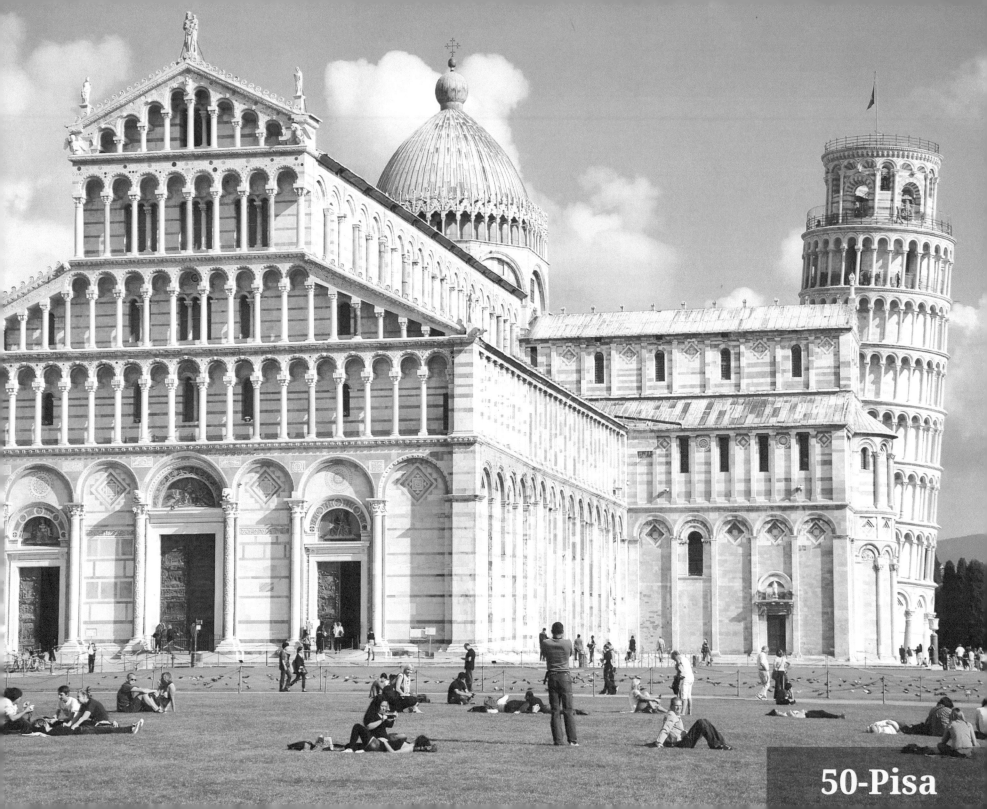

50-Pisa

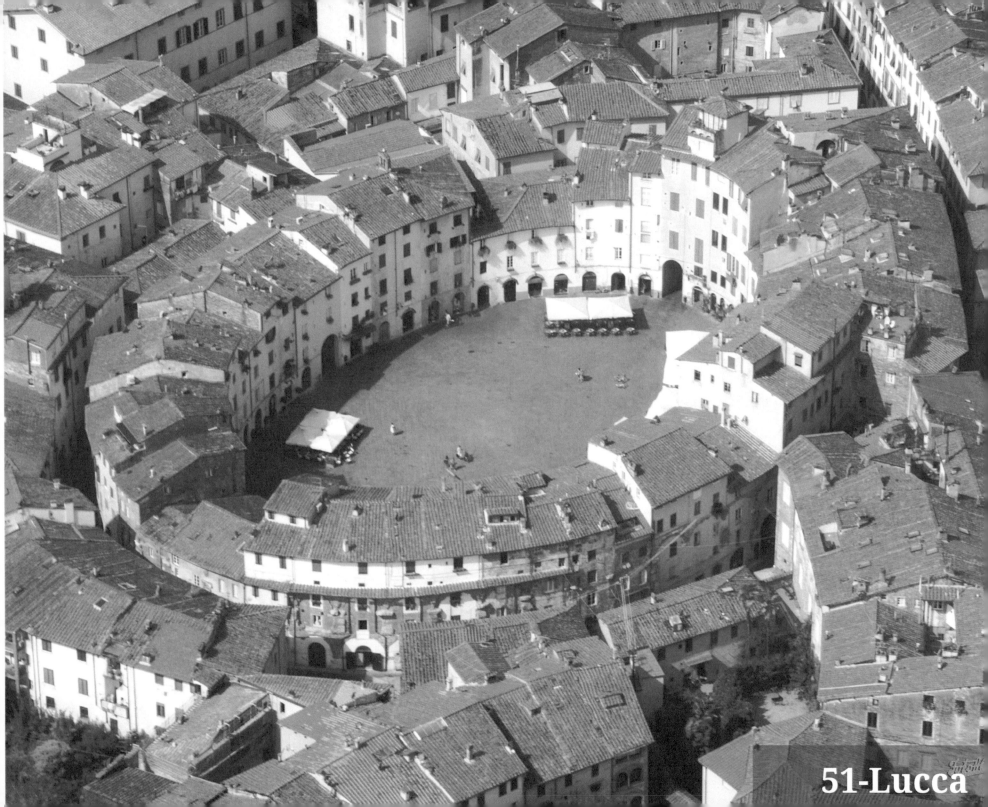

51-Lucca

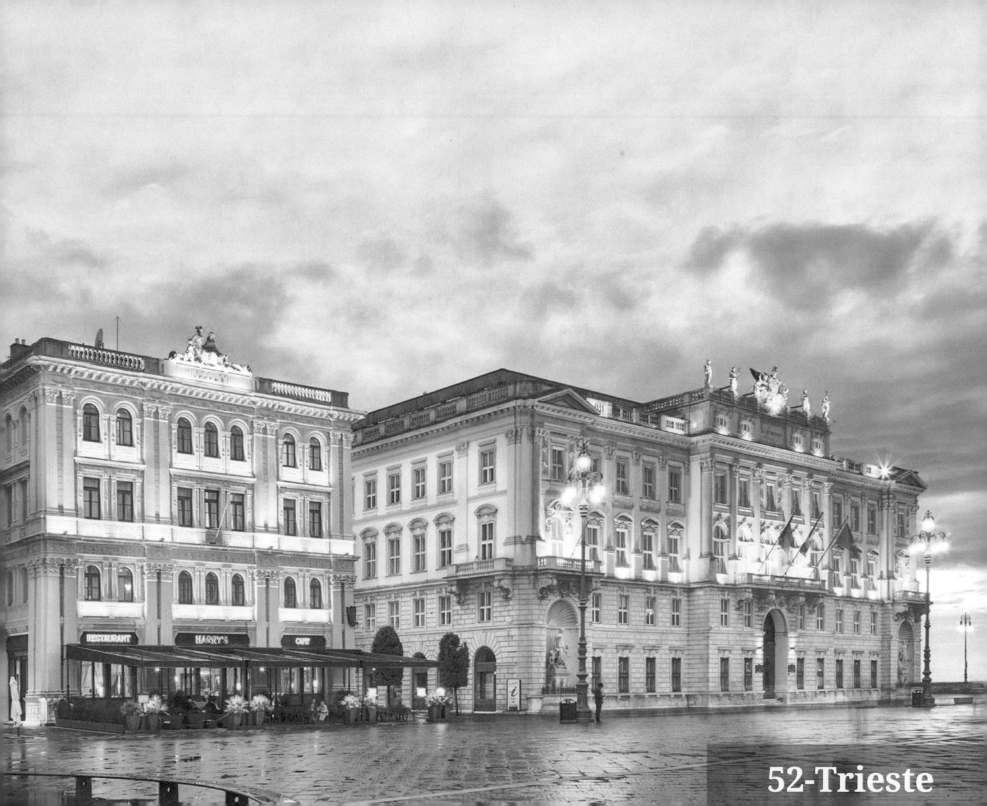

52-Trieste

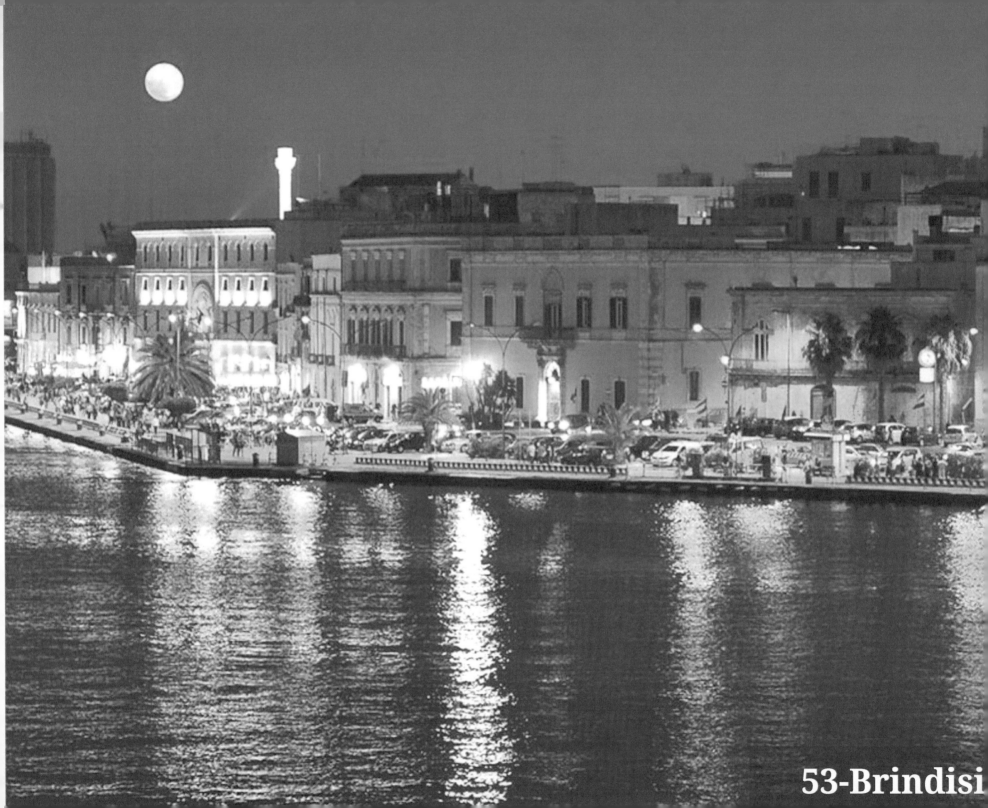

53-Brindisi

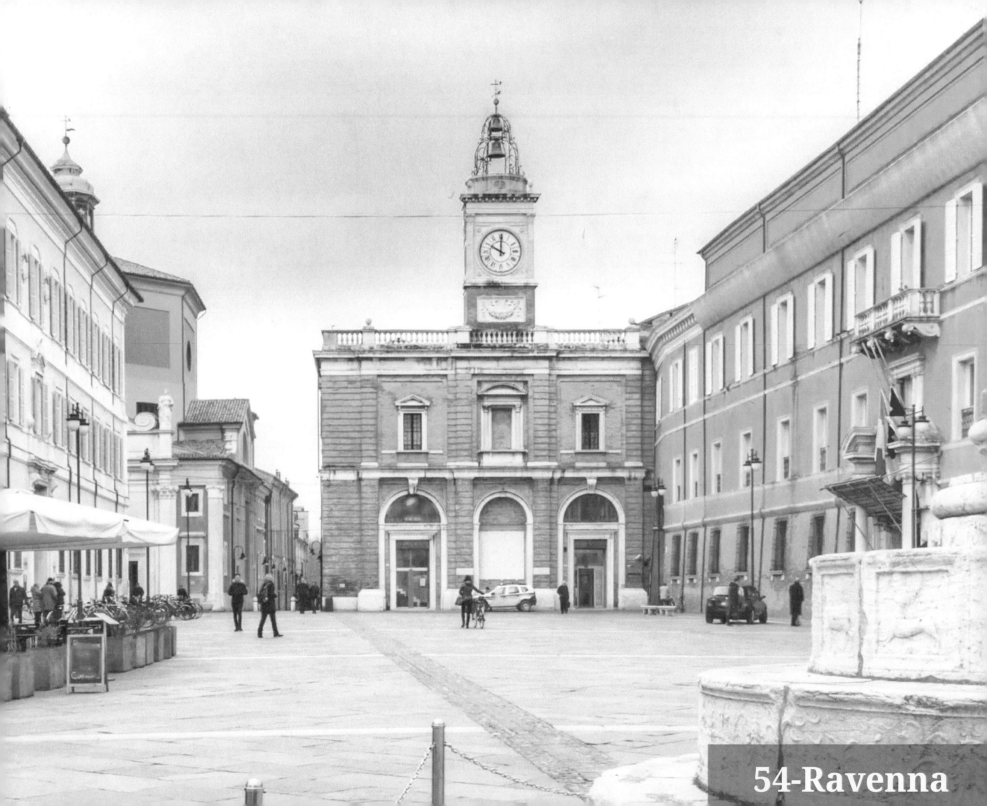

54-Ravenna

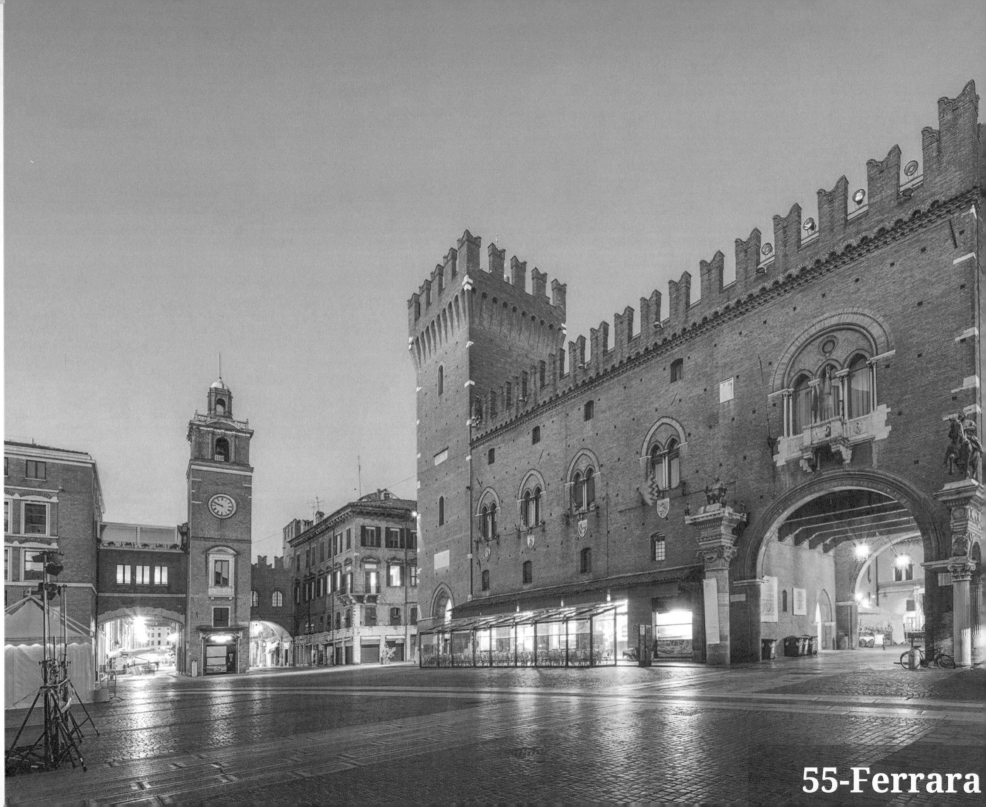

55-Ferrara

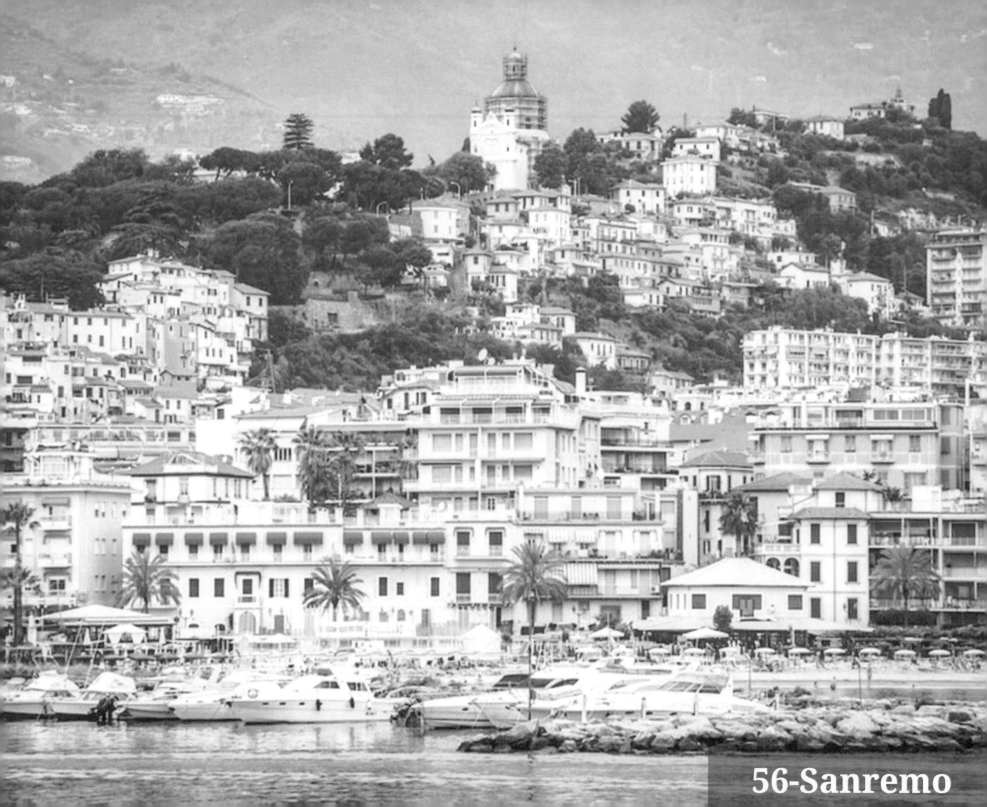

56-Sanremo

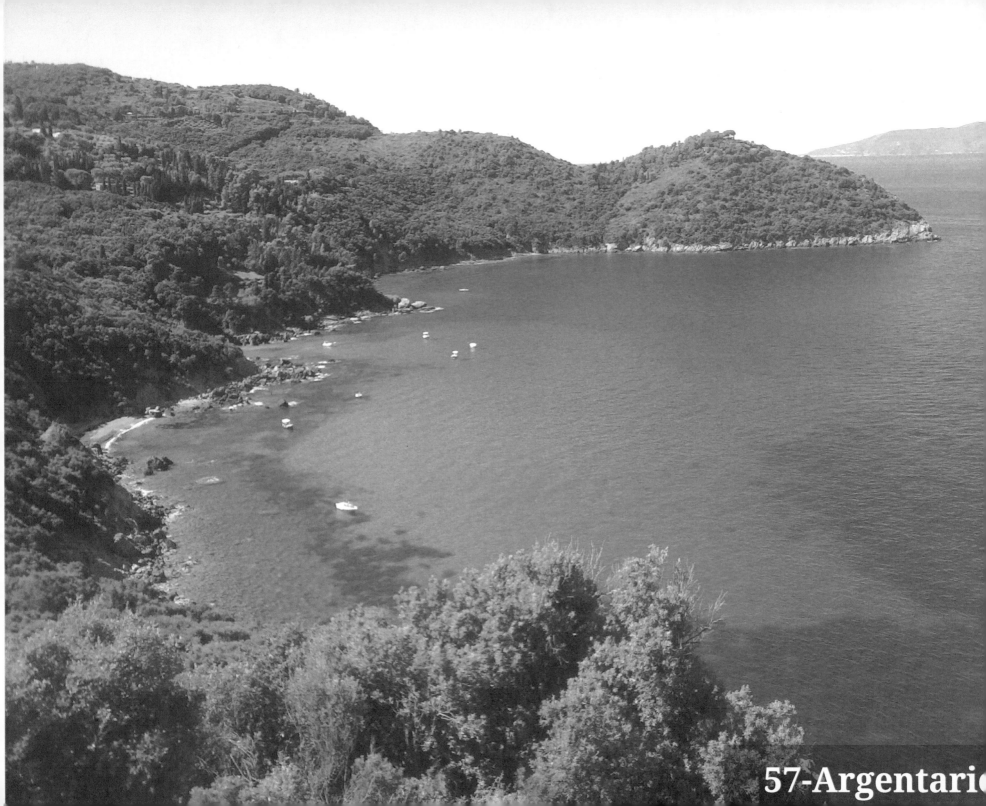

57-Argentari

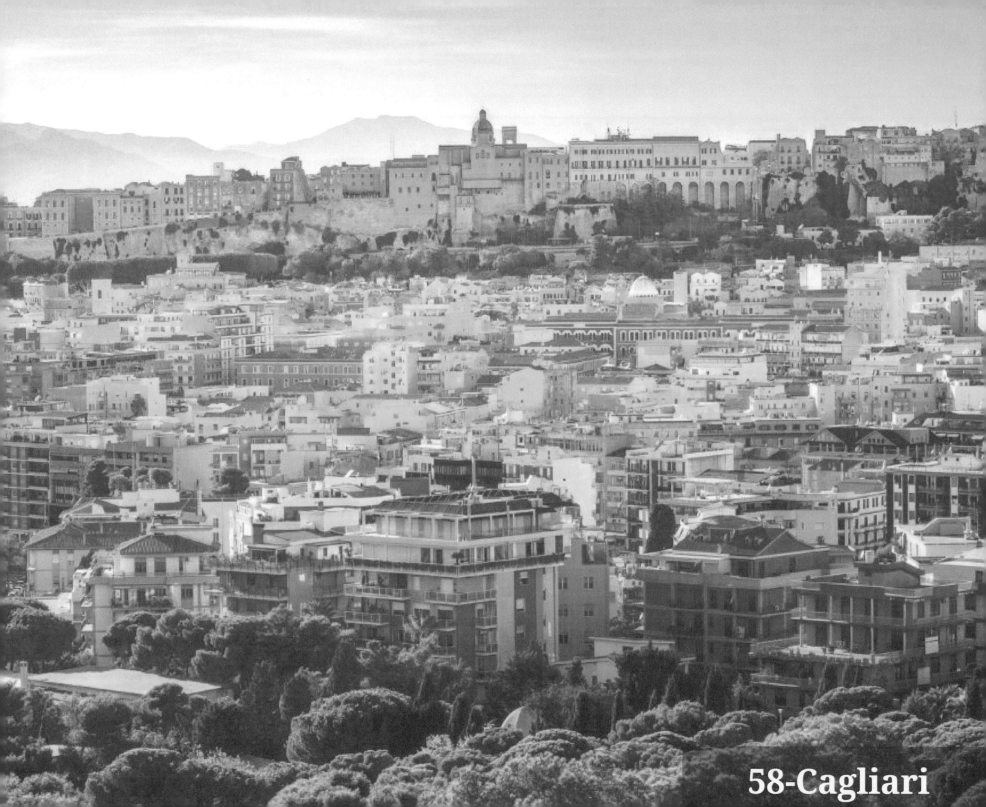

58-Cagliari

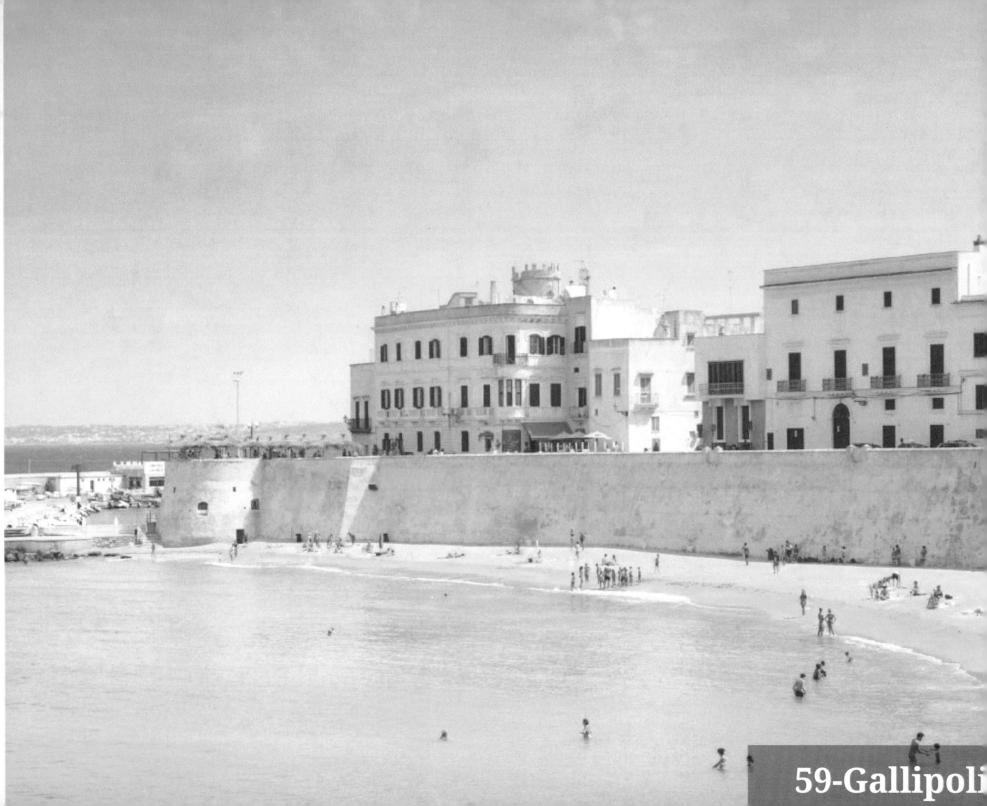

59-Gallipoli

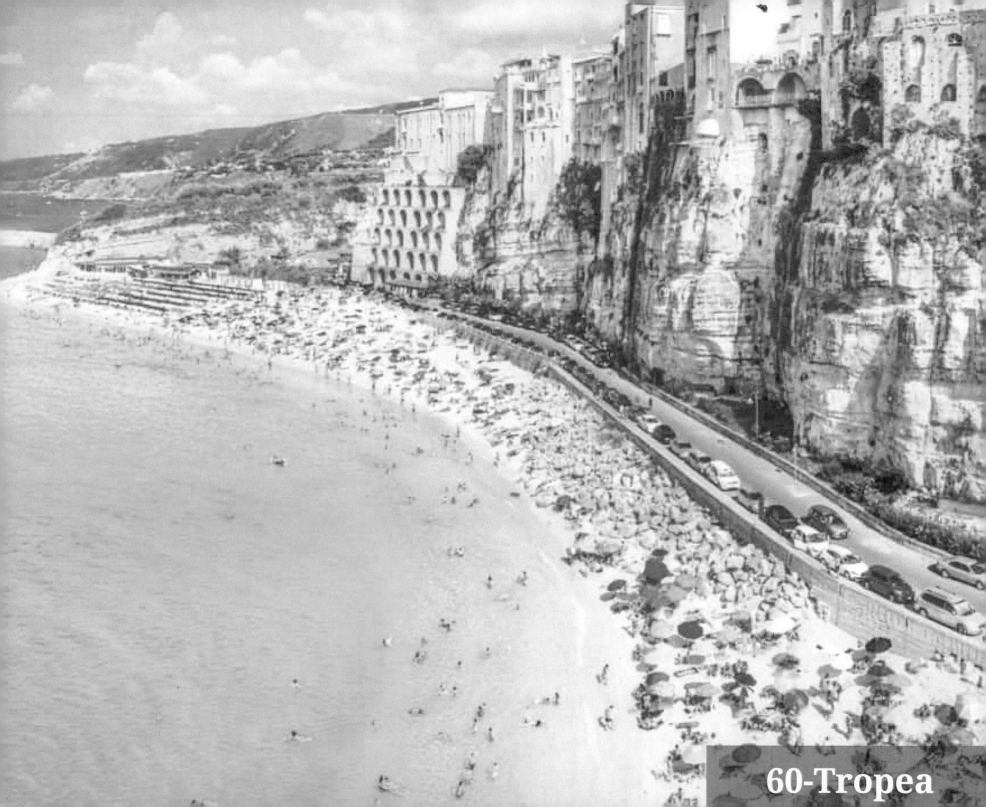

60-Tropea

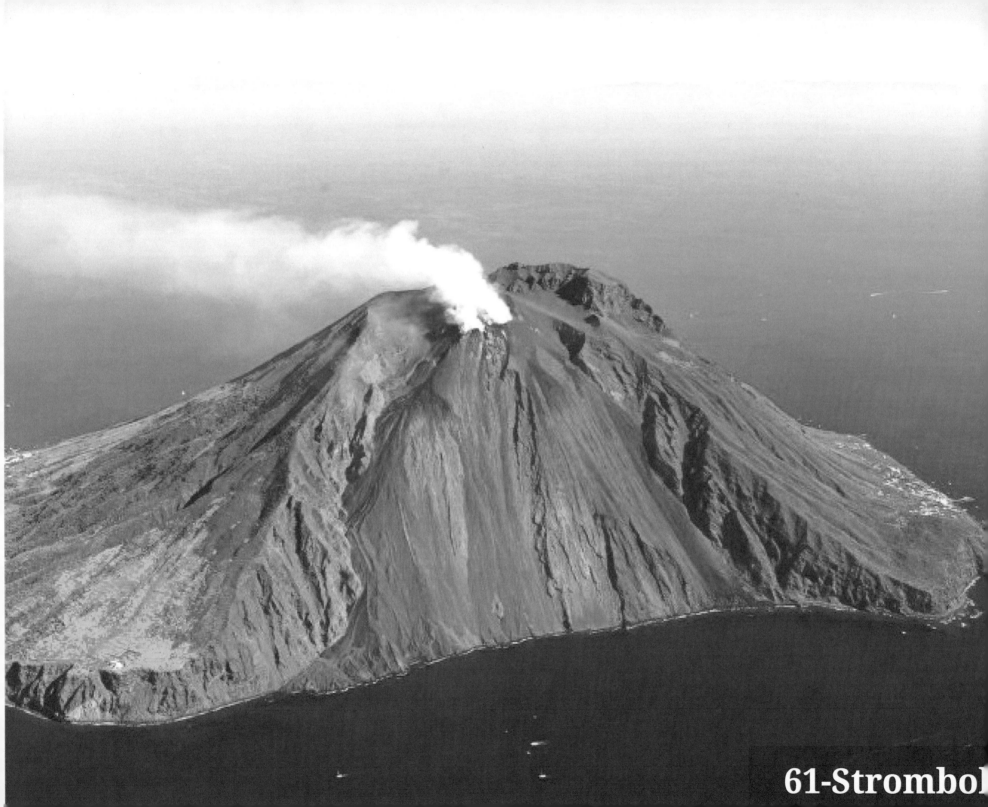

61-Stromboli

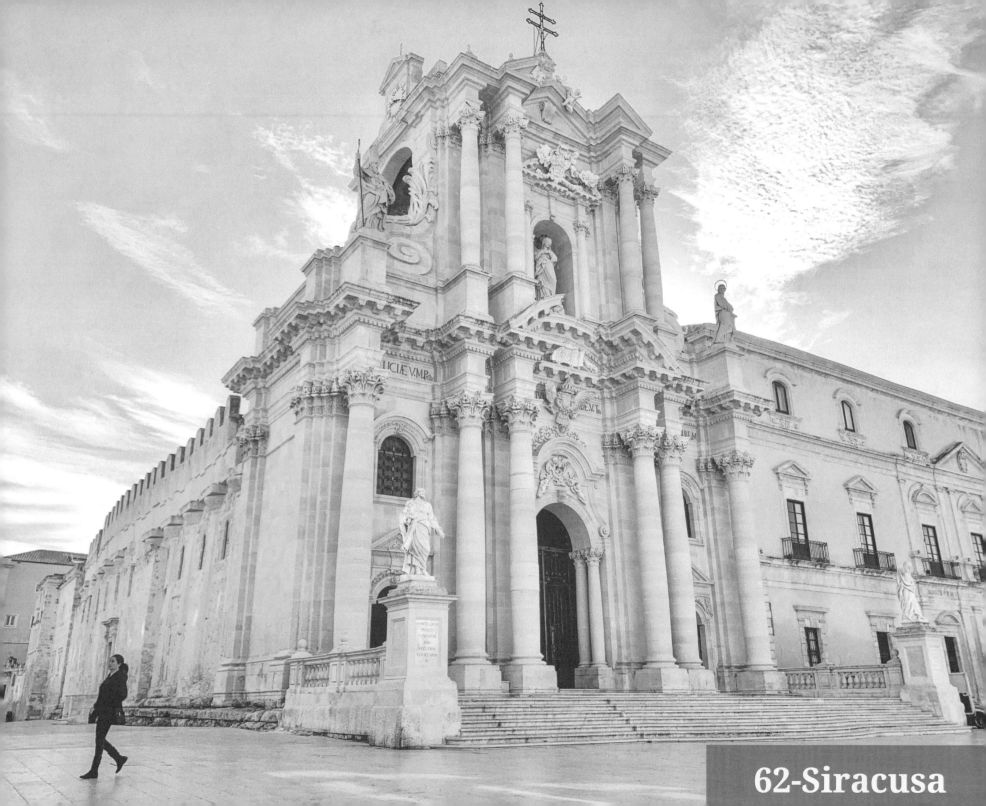

62-Siracusa

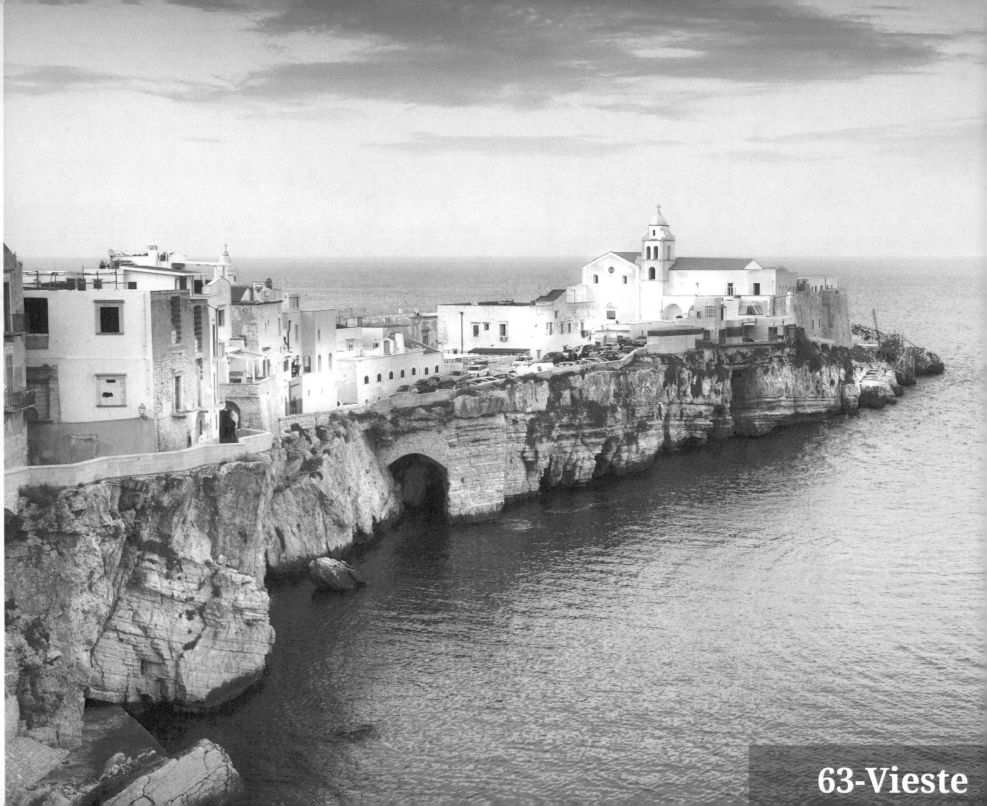

63-Vieste

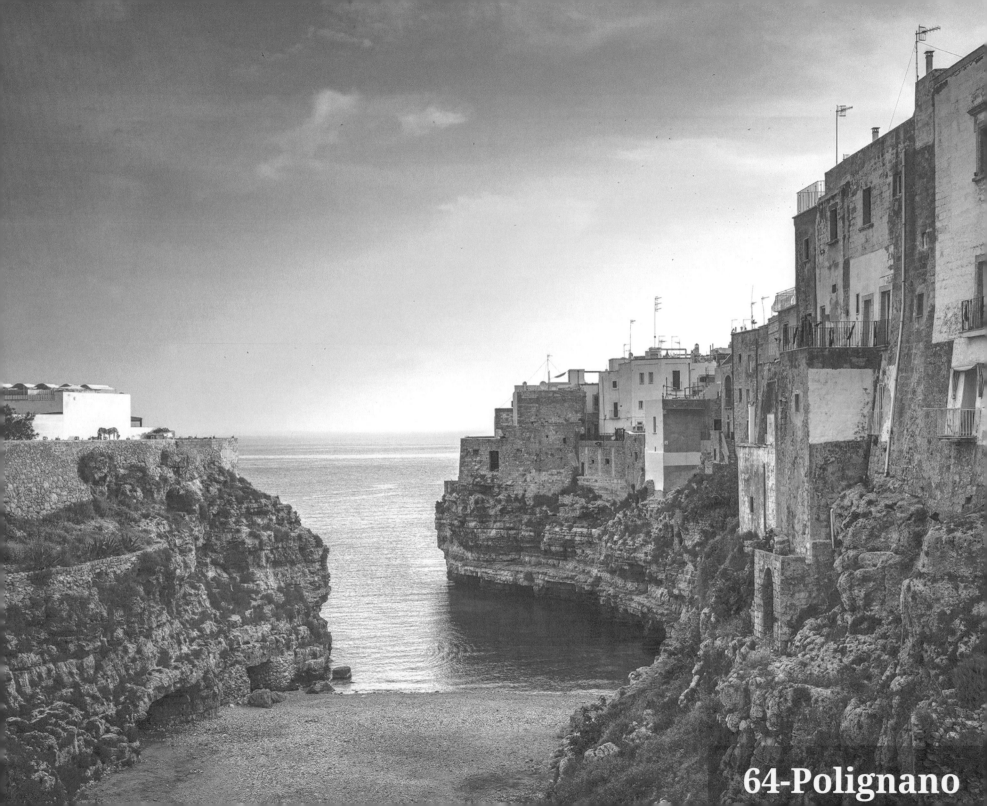

64-Polignano

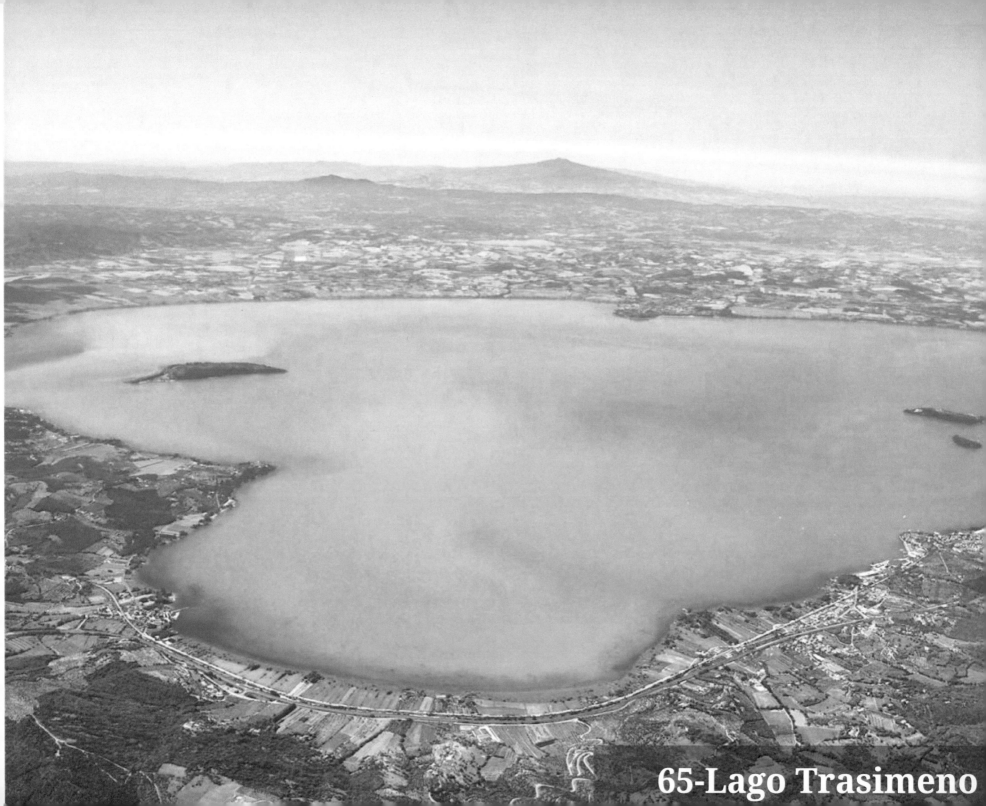

65-Lago Trasimeno

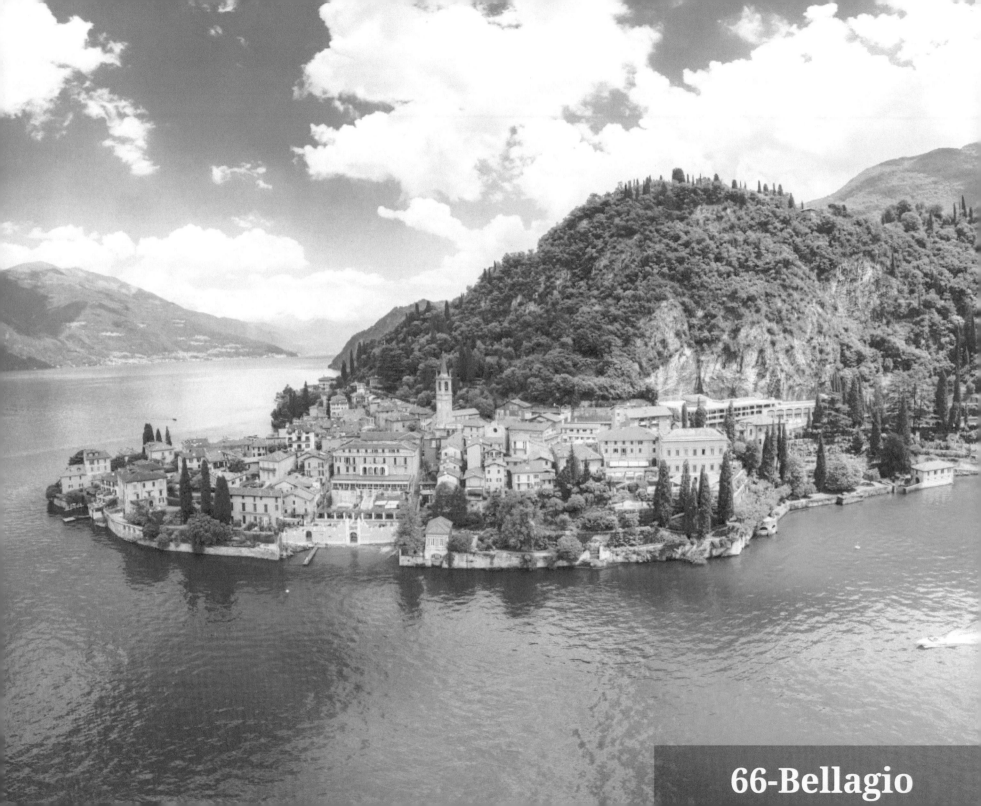

66-Bellagio

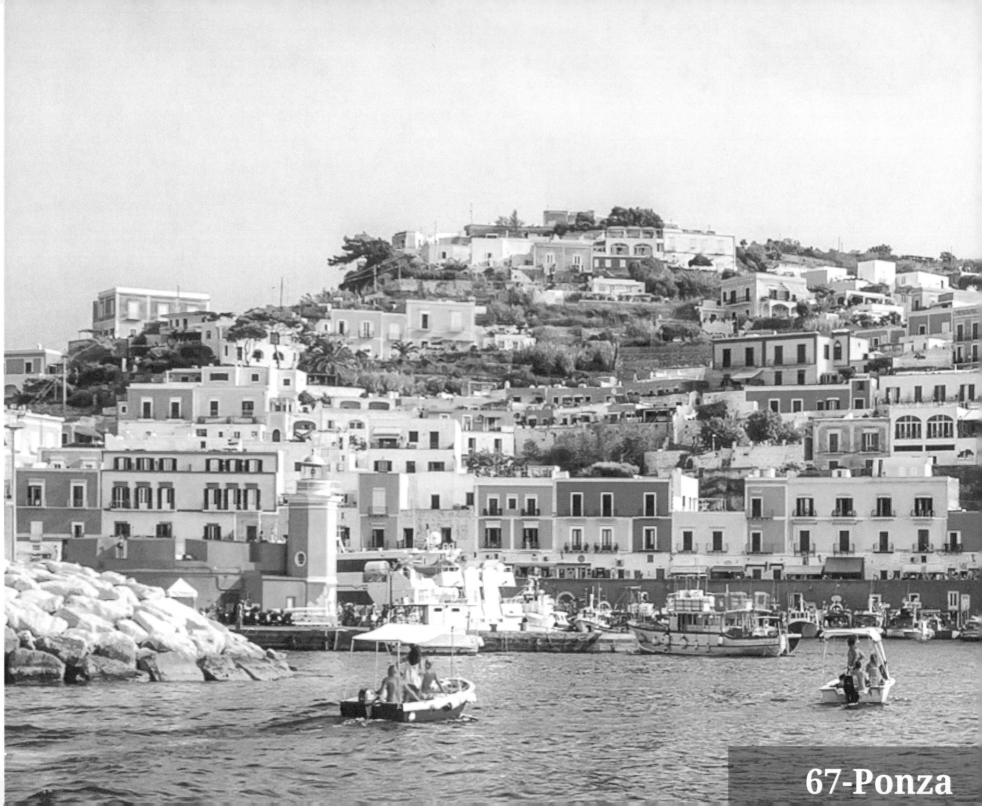

67-Ponza

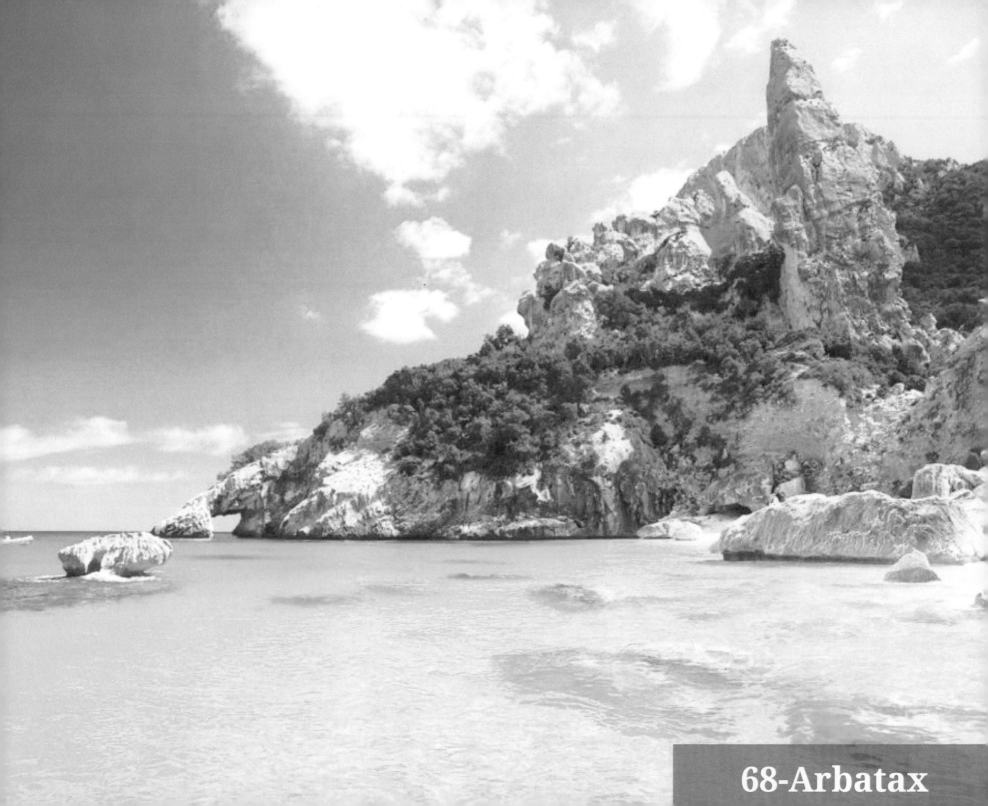

68-Arbatax

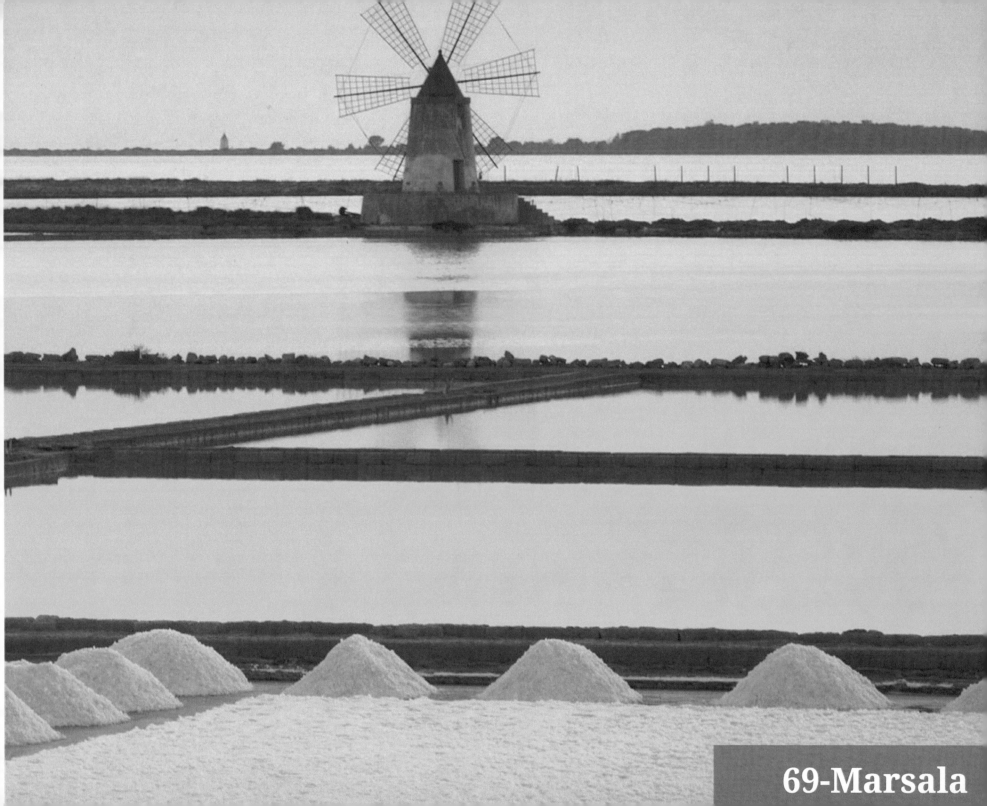

69-Marsala

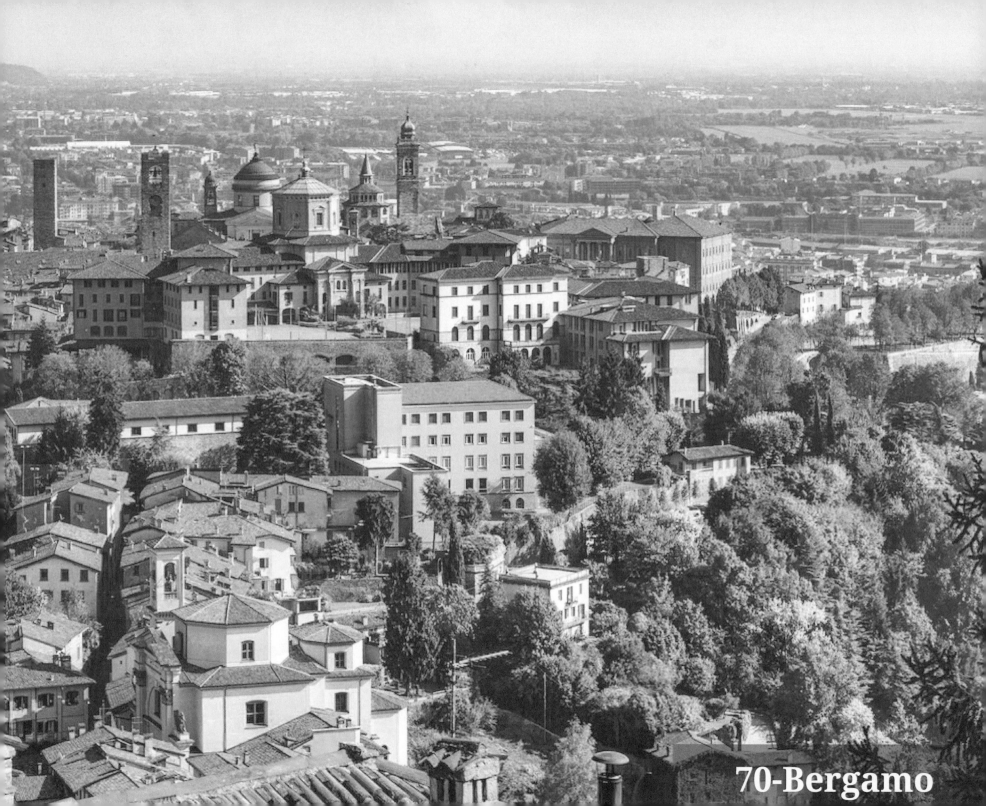

70-Bergamo

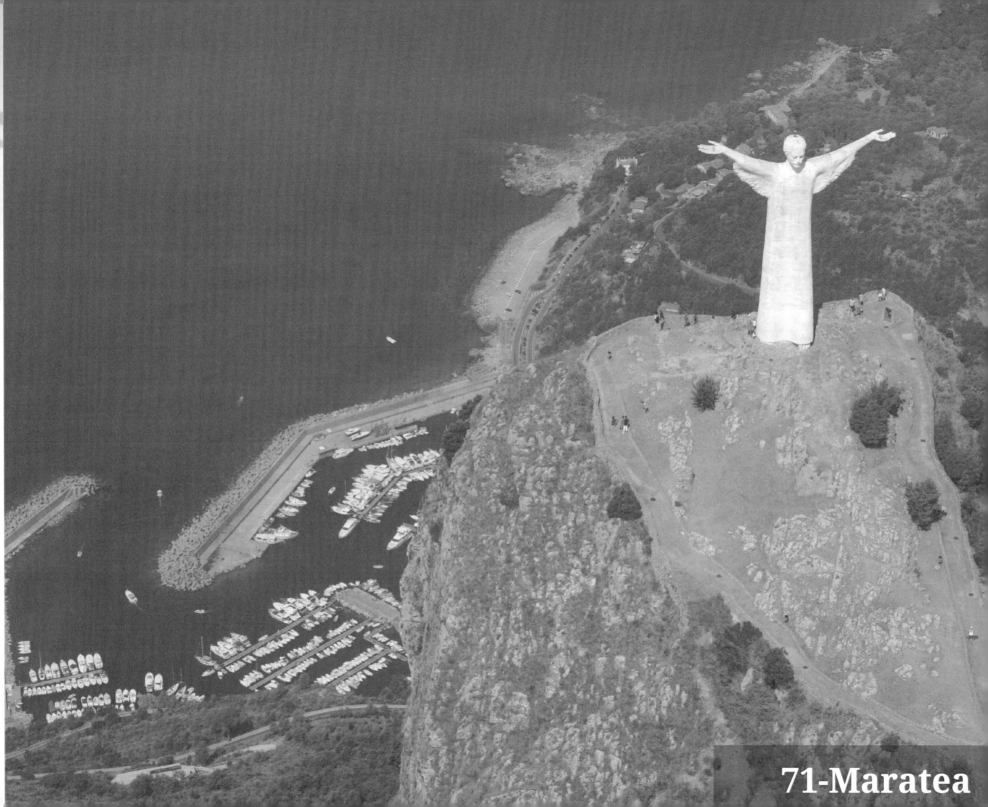

71-Maratea

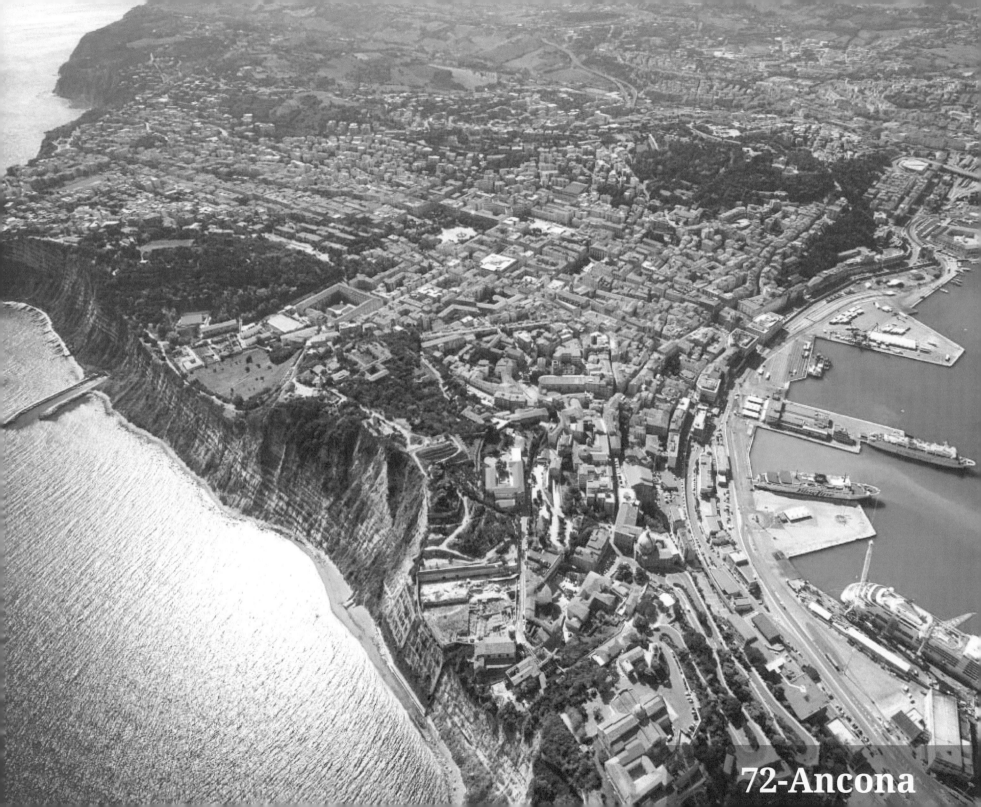

72-Ancona

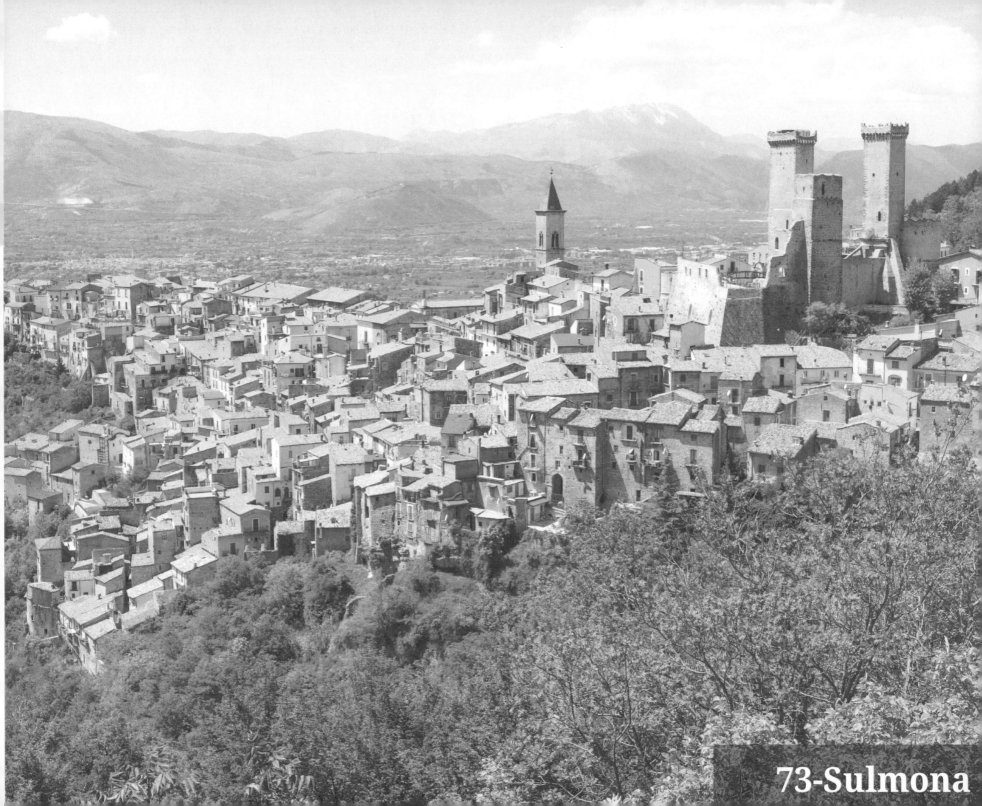

73-Sulmona

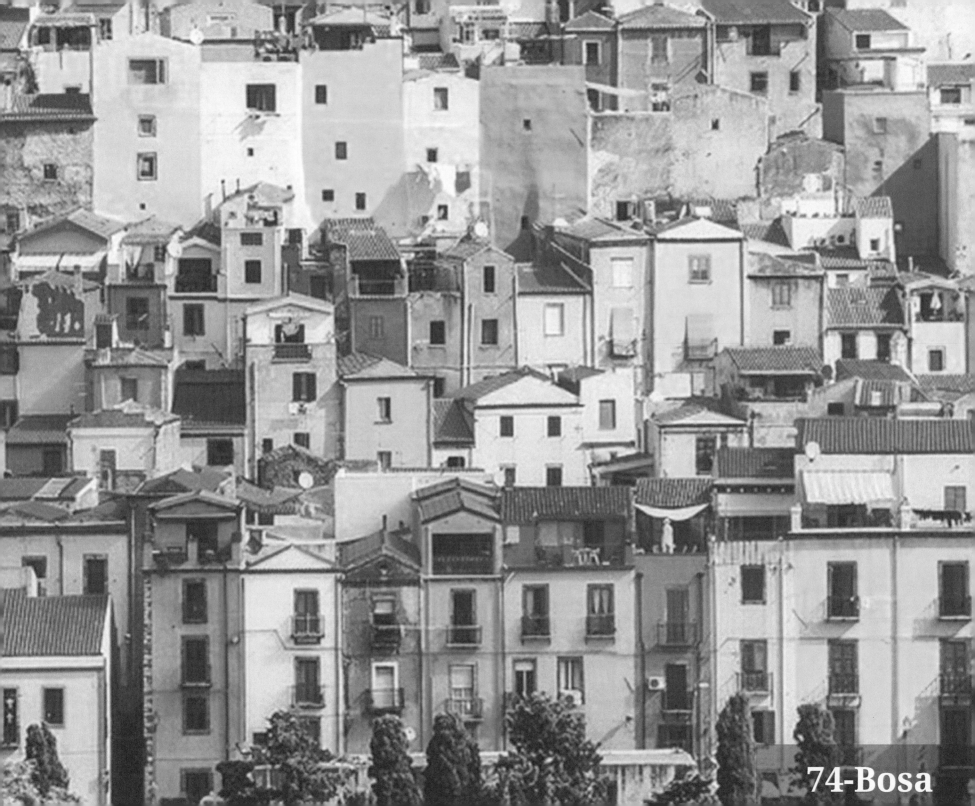

74-Bosa

ITALY IN LOVE 🖤

CPSIA information can be obtained
at www.ICGtesting.com
Printed in the USA
BVRC100958260421
605862BV00011B/261